A–Z

OF

LIVERPOOL

Places - People - History

Ken Pye FRSA

AMBERLEY

First published 2017

Amberley Publishing
The Hill, Stroud, Gloucestershire, GL5 4EP
www.amberley-books.com

Copyright © Ken Pye, 2017

The right of Ken Pye to be identified as the
Author of this work has been asserted in
accordance with the Copyrights, Designs and
Patents Act 1988.

Map contains Ordnance Survey data © Crown
copyright and database right [2017]

ISBN 978 1 4456 6680 8 (print)
ISBN 978 1 4456 6681 5 (ebook)

British Library Cataloguing in Publication Data.
A catalogue record for this book is available
from the British Library.

Origination by Amberley Publishing.
Printed in Great Britain.

Contents

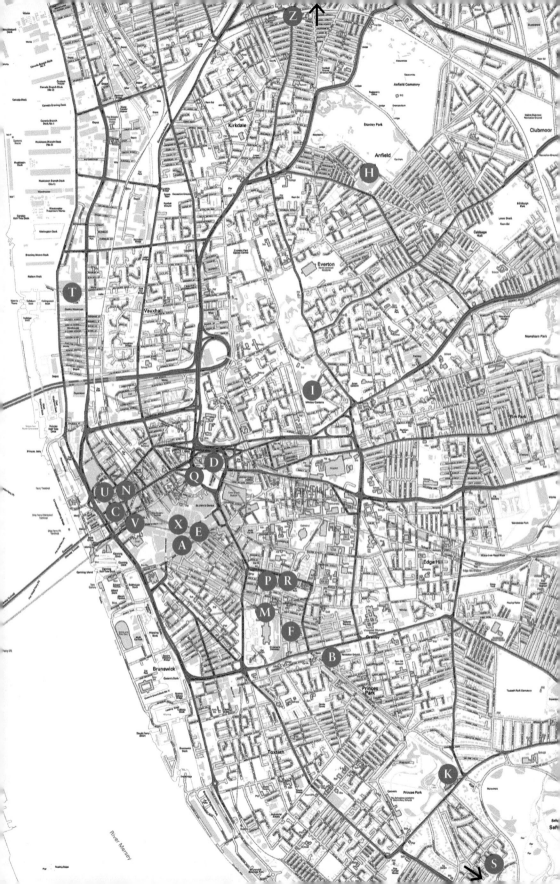

Zoomed section

Introduction

This book is best described as being 'An A to Z of Lesser-known Liverpool'. This is because I have quite deliberately omitted the city's most famous buildings, locations, monuments and people, all of which can all be read about in detail in many other books – especially my own!

This time I thought it would be much more interesting, informative, and fun to simply include an alphabetical selection of people and places that are much less familiar, if not entirely unknown, with only one or two special exceptions, although I suspect that there are more than a few references here that will indeed be completely new to most people, including Liverpudlians!

So, you are not about to read about the Liver Building, Bessie Braddock, St George's Hall, Dickie Lewis, or The Pier Head. However, and among much more, you will read about King John's thirteenth-century Hunting Lodge, Gog and Magog, the Hillsborough Memorial, Brian Epstein, the Pyramid Tomb of Rodney Street, the Walton Zoo and Pongo the Man Monkey, the secret Underground War Museum, Little Bongs, and the old Tudor Woolton Schoolhouse where a seventeenth-century Catholic martyr went to school as a boy. Best of all, these are all easy to find and quite accessible.

In these twenty-six chapters I present a potpourri of places and people that range from the stunning and stimulating to the unusual and entertaining. Together, these paint a true picture of the genuinely diverse community and historically significant city on the banks of the Mersey.

One of my greatest pleasures as an author and historian is to produce a 'well I never knew that!' reaction from my readers, and I hope this book results in quite a few of these. Even though many of my choices do fall outside mainstream knowledge, they all have the most entertaining stories to tell and secrets to reveal. Also, they are each significant in the history and heritage of the city and beyond.

It has been difficult reducing the available subjects down to only twenty-six, but I do hope that you approve of, and thoroughly enjoy, my final selection.

Ken Pye
Liverpool, 2017

A

Athenaeum Club – Liverpool's First Gentlemen

In 1086, twenty years after his conquest of England, William the Conqueror ordered the production of the Domesday Book. This was the Norman king's great ledger of everything he owned and could tax in his newly subjugated country. However, Liverpool is not listed in the huge tome because the town was not founded until 1207, by King John (1167–1216). He came to the otherwise isolated and obscure fishing hamlet because of its very large, deep tidal pool off the River Mersey. This was fed by a broad creek rising in the adjacent hills that still looks down over the River Mersey.

John intended to invade Ireland, and then Wales, Scotland, and the Isle of Man, and the pool would provide a natural harbour for his great fleet of warships. The king created the town and borough of 'Leverpul' to establish a growing community and economy to service his ambitions. As the core of his new town, he ordered seven streets be laid out. These survive in the same positions they were laid out, but now as the heart of the modern, thriving, world-class city.

Over the next 500 years Liverpool only grew slowly. That was until, in 1715, the world's first enclosed commercial wet dock was built, and opened on the site of the ancient pool and creek that had first attracted the king here.

Throughout the eighteenth century in particular, the town of Liverpool now began to expand at an unprecedented rate, in terms of its economy and culture, as well as in its population numbers. While this inevitably created great poverty, it also generated entrepreneurship, creativity, industriousness, and a striving for intellectual and social evolution. One of the greatest symbols of this is the Athenaeum Club. This stands on one of Liverpool's oldest streets, Church Alley, off Church Street in the city centre, although this was not the club's first location.

By the final decade of the eighteenth century Liverpool was already one of the world's major ports. Its increasing number of merchants and shipowners, and its professional classes, were shrewd and ambitious for success in all its manifestations. These men recognised that real achievement comes from knowledge, which itself comes from information, especially political and commercial information.

The usual way to obtain this at that time was in broadsheets, pamphlets, newspapers and periodicals. But these were not always easy to obtain and were generally expensive. They were also often only available in noisy and overcrowded coffee houses. So, early in 1797, a group of Liverpool's leading men met to plan the founding of a learned institution, and to raise funds to commission a building as the home for what would also become one of the town's first exclusive, private gentlemen's clubs.

Though often of widely differing political and professional opinions, these men held a shared purpose in common. This was to acquire knowledge, and then to share this and put it to practical and profitable use. They were also determined to use any advantages, power, wealth, or authority, that they then gained, to the benefit of the people and town of Liverpool, and of the country generally.

On 22 November of that same year they formally constituted an institution for learning, and named it the 'Athenaeum' in honour of Athena, the Greek goddess of wisdom. The Roman name for this important deity was Minerva and she is the patron goddess of the city. Her statue sits on the dome of Liverpool Town Hall.

At its inception the Athenaeum had 350 subscribers, who each bought a non-income-generating share at 10 guineas, thus becoming known as 'proprietors'. Members are still referred to by this term today. Each proprietor then paid an initial annual subscription of a further 2 guineas. With this fund, the institution's first premises were purpose built at a cost of £4,000, and opened on 1 January 1799.

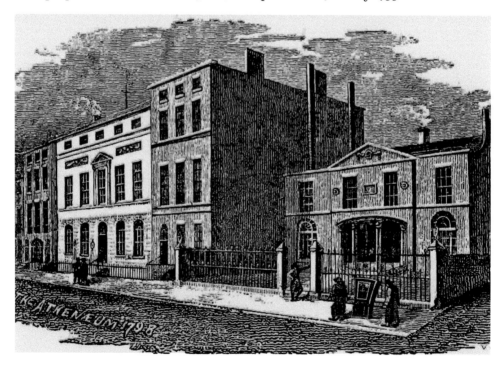

The first Athenaeum Club building in 1798, shown second from the left. (Athenaeum Library)

With a cellar, two floors for the use of proprietors, and a servants' garret, the 'Athenaeum Club' was well appointed, very spacious, extremely comfortable, and exclusively for the use of proprietors and their guests. It stood on the original, much narrower Church Street (laid out from the beginning of the eighteenth century), near the end of modern Parker Street.

The ground floor consisted principally of a newsroom, for conversation, discussion, reading, and study. This was also where groups of proprietors met to create opportunities to grow the economy, culture, and influence of the town, as well as the wellbeing of its citizens.

In the rooms on the upper floor, even from the earliest years of the Athenaeum's existence, was an extensive, valuable, and comprehensive collection of books that today comprises over 25,000 volumes. A number of these were from the private library of a founding member of the Athenaeum, William Roscoe (1753–1831). In later years, this library grew into what remains one of the world's most highly regarded private literary collections.

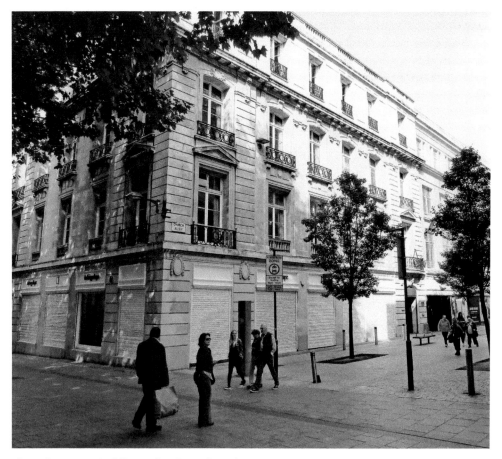

The Athenaeum Building today. (DL Library)

Preceding its London namesake by twenty-seven years, over the following decades the institution was to also amass an excellent collection of navigation charts, maps, globes, reference works, watercolours and sketches, and early satirical cartoons.

The first Athenaeum proprietors were entrepreneurs, industrialists, merchant adventurers, speculators, freethinkers, and political radicals. Some were also slave and plantation owners and traders; slavery was one of the principal sources of income for many in the town at that time. Nevertheless, many Athenaeum proprietors were slavery abolitionists, the most passionate of these being William Roscoe. He was also one of the town's most remarkable 'renaissance men', being an author, biographer, poet, botanist, astronomer, radical politician, and campaigner for social justice.

Most of the club's gentlemen saw it as their duty, as well as their pleasure, to fund charitable institutions, and build hospitals, schools, orphanages and churches. They sponsored music, opera, theatre and the arts, and saw themselves as the commercial and intellectual champions of Liverpool, and also as the drivers of its expansion, prosperity, and social growth. The Athenaeum's membership reflected the energetic diversity of the town that had, by the closing decades of the 1700s, already become the 'Second City of the British Empire' outside London.

As soon as it had been established, the Athenaeum became immediately popular. Admission to its membership was much prized so, on 1 July 1799, the committee decided to admit seventy-five new members at 20 guineas each. These were all taken up within twenty-four hours. There were then 425 proprietors and, in July 1800, a further seventy-five were accepted, now at 30 guineas each. These places were again filled within a day, and 500 remains the maximum permitted number of full proprietors.

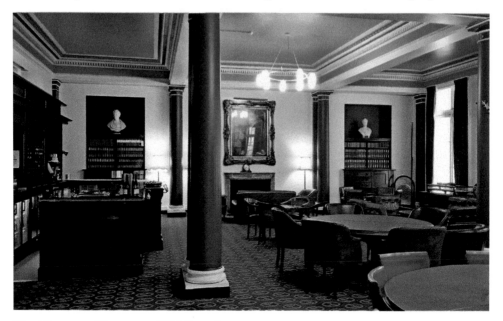

The Athenaeum Newsroom. (DL Library)

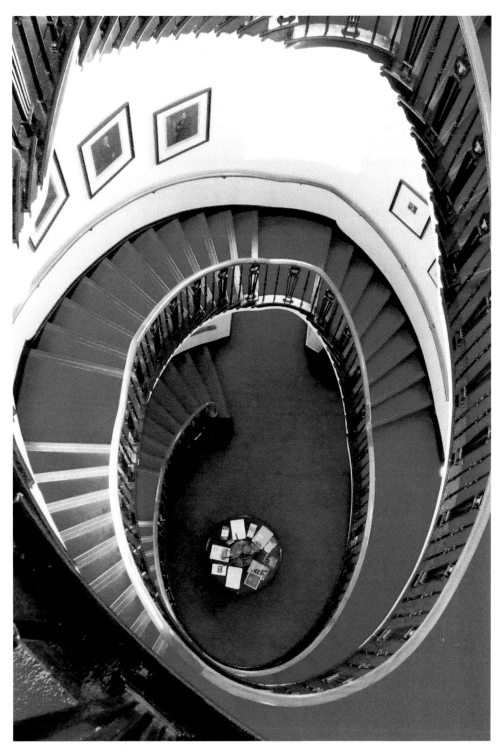

The outstanding cantilevered staircase. (DL Library)

However, in the 1920s, the Corporation of Liverpool needed to widen Church Street to accommodate a new tram system through the city, and so in 1928 the Athenaeum moved to its current, much larger, premises in Church Alley. Although the design of this building is clearly early twentieth century from the outside, inside you could believe that you were visiting the private apartments, ballrooms, and studies of an eighteenth-century stately home.

Still with the newsroom at its heart, there are now two floors of library stacks with an adjoining, elegant reading and conference room. Serviced by a comprehensive, efficient 'backstage' infrastructure, and a team of highly skilled and professional staff, there is also a committee room, a meeting room, offices, a bistro-style bar, a full-service dining room and a wine servery.

For over 220 years the Athenaeum and its library have provided outstanding facilities and resources to some of the most significant individuals in Liverpool's and the nation's history; people such as Dr William Duncan, Sir James Picton, Thomas Brocklebank, Bishop Chavasse, Sir Ronald Ross, and very many others too numerous to mention here.

The Athenaeum remains a place to meet and engage with senior professionals from all walks of life, while also being somewhere to research, relax, and retreat to, in what the institution accurately describes as, 'a haven in the heart of Liverpool that offers a distinguished setting and an atmosphere unrivalled in the City'.

The Athenaeum is run as a not-for-profit organisation and the present proprietors maintain the traditions, standards, and positive objectives of the club. It remains open to all, regardless of age, race, gender, faith, politics, or sexual orientation. Its only qualifications for membership are that you are of good standing, have personal and professional integrity, and are determined to share knowledge to the benefit of civil society.

Because this is a private members' building, the Athenaeum is not generally open to the public, although it can be hired for conferences and meetings, and it is also licensed for weddings, civil ceremonies, and other private celebrations and functions.

My obvious passion for the Athenaeum is a giveaway of the fact that I too became an enthusiastic proprietor of the institution some fifteen years ago. As such, I urge you to take the opportunity to book a visit to the club premises if you can.

B

Bowes Museum of Japanese Artwork, Streatlam Tower

From the Georgian Quarter of Liverpool, a broad boulevard, named Princes Road, leads to one of the city's first, great public parks, Princes Park. When this drive was created, in the mid-nineteenth century, it was originally the route for carriages transporting the gentry between the town and their grand mansions to the new and beautifully landscaped park. This had opened in 1842, and was the talk of Liverpool and beyond.

The park had originally been created as a private venture, but it quickly became the model for the wonderful range of public parks that were subsequently opened by Liverpool Corporation, right across its rapidly expanding and densely populated conurbation. Liverpool's parks were to become the 'lungs of the town' and they are still much used and deeply loved by the people.

However, at the city end of Princes Road, on the east side, are four outstanding buildings. First is the former District Nurses Training School. This opened in 1898, and was the result of a pioneering partnership between a wealthy local philanthropist, William Rathbone (1787–1868), and the famous pioneering nurse, Florence Nightingale (1829–1910). Next to this is the beautiful Church of St Margaret of Antioch, built by renowned church architect Robert Horsfall (1807–81) in 1869.

Further along the road is one of the most beautiful synagogues in Europe. This was consecrated in 1874, and was built by the equally renowned architects William and George Audsley. However, the imposing building that stands between the church and the synagogue, at No. 5 Princes Road, was erected as a grand, private mansion house, by James Lord Bowes (1834–99). Named 'Streatlam Towers', in 1872 he had commissioned this as his family home, and it certainly has an individual yet attractive style, somewhat reminiscent of a medieval Scottish baronial mansion.

Constructed in brick, stone, and slate, with towers, mullioned and lancet windows, and tall chimneys, one of the building's outstanding features is its distinctive, round, staircase tower with its fairy-tale castle roof. While the exterior of the house has neo-romantic stylings, inside it had oriental designs, fixtures, and fittings, which is reflected in another particular feature of the large house. This is the protruding ground-floor doorway and roofed passageway, to the left of the main building.

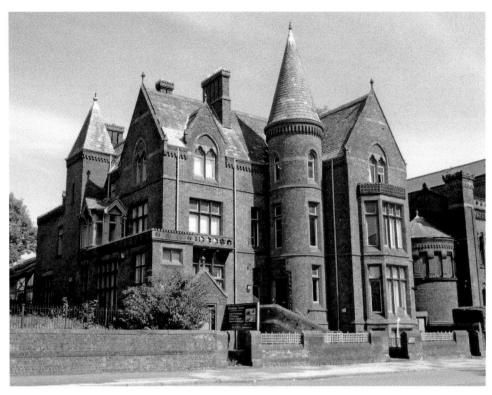

Streatlam Towers, once the home of the Bowes Japanese Museum. (DL Library)

This was formerly the entrance to the Bowes Museum of Japanese Artwork, which was then the first dedicated museum of such art in the western world. The lintel of this small and unassuming doorway, and the decorated parapet of the wall above, are carved with reliefs of chrysanthemum flower heads. These are one of the symbols of Imperial Japan.

James Lord Bowes had been born in Leeds as the youngest of six children. He and his family moved to Liverpool sometime between 1840 and 1845, following the unexpected death of his father. Upon leaving school, John worked as a clerk in a general merchant's office, where he learned many skills. These included a detailed understanding of the cotton and wool trades, which were then among Liverpool's principal industries.

Indeed, his expertise and confidence were such that, at the age of only twenty-two, James and his brother, John, set up the firm of John L. Bowes & Brother, wool brokers. This was so profitable that, in 1859, the company moved to magnificent new headquarters in the stunning Queen Building, which still stands on Dale Street. James then began to travel the world in search of new business opportunities and it was from this time that he discovered and fell in love with all things Japanese.

The business rapidly prospered, and James and his family now moved to a much grander home in Canning Street, in what is now Liverpool's Georgian Quarter. But

by 1867 James was thirty-three years old and wanted his own home, so he bought Streatlam Cottage. This was a small but delightful house set in its own grounds adjacent to Strawberry Field in the Woolton suburb of Liverpool. Strawberry Field was, of course, later to be made famous in a song by John Lennon and Paul McCartney. Marrying in 1871, James and his wife, Charlotte, went on to have six children. The last surviving of these was Ruth, who died in 1967 at the age of ninety-four.

James was a prominent figure in the business and cultural life of Liverpool, becoming vice president of the Liverpool Chamber of Commerce and president of the Liverpool Artists Club. It was from around 1867 that he began his collection of Japanese art of all types, but especially ceramics. He also established commercial and political links with 'the land of the rising sun', which gained him recognition and status in both countries. Indeed, in 1888 the Emperor of Japan appointed James as 'His Imperial Majesty's Honorary Consul for Japan at Liverpool'. This was the first such diplomatic post that Japan had in Britain, and so was of landmark significance for both countries, especially as, before this time, relations between the two nations had been far from friendly.

At Streatlam Towers, in 1890, James opened his Japanese museum to the public in and it was an immediate success. Said to be the finest such collection anywhere in the world including Japan, this was valuable, exhaustive, eclectic, and fascinating, and so proved to be extremely popular with Liverpudlians from all walks of life. Long queues regularly formed along Princes Road, of people patiently waiting to glimpse for themselves what was, at that time, only a recently revealed and very strange culture from the other side of the globe.

As well as portraits and paintings, also on display were books, fine silks and textiles, costumes, ivory and wooden carvings, ceramics, porcelain, exquisite lacquer-ware, and other artefacts. The museum was open throughout the year.

In April 1891, James hosted a 'Japanese Fancy Fair' in his museum. This attracted 20,000 people in six days and raised £5,290 (£580,000 at today's value), which was all donated to charities in the city. In May of the same year James was awarded the 'Japanese Order of the Sacred Treasure, 4th Class', and in February 1897 he received the 3rd Class rank of the same honour.

James Lord Bowes died on 27 October 1899 of a heart attack, suffered while travelling on a train from London to Liverpool. He is buried in Toxteth Park Cemetery, on Smithdown Road in Liverpool.

His Museum of Japanese Art closed immediately after his death and concerted attempts were made to keep his collection intact and find it a new home. Sadly, these efforts failed and, in 1901, an eleven-day public auction was held. The wonderful collection was sold off piecemeal, although some of the artefacts do remain in the city in various collections.

Streatlam Towers still stands as a glorious monument to late nineteenth-century, grand, private, residential architecture. It is also a silent and anonymous monument to a man of individuality, influence, authority, and very distinctive taste. The palatial building has now been converted into apartments for students.

Chorley Street – The Road in Disguise

When, in 1207, King John founded Liverpool, the original seven streets that he ordered to be laid out eventually became known as: Chapel Street, where the church of Our Lady and St Nicholas stands on the site of the very ancient Chapel of St Mary del Quay; Old Hall Street, which once led to the ancient family seat of the wealthy More family; Tithebarn Street, on which, as its name suggests, the old Tithebarn stood; Juggler Street (now High Street), running alongside the Town Hall, is where itinerant acrobats, players, and musicians entertained the medieval townsfolk; Castle Street, which led to the great castle (more on this later); and Dale Street, which led to a pretty embankment on the wide creek that once fed the great Pool.

The seventh ancient thoroughfare is Water Street. This originally led directly to the banks of the Mersey, and was the point from which early travellers boarded and disembarked their sailing vessels.

Over the years networks of narrow alleys, passages, and roadways began to branch off these first streets, and one such was Chorley Street. This ran from Water Street in the direction of the castle and the pool and, by the beginning of the nineteenth century, there were a mixture of court dwellings, lodging houses, and a number of commercial office premises lining both its sides.

On the eastern corner of Chorley Street and Water Street a large office block and warehouse had been built in 1834 by George Holt (d. 1861), who was a wealthy cotton broker. He had named it 'India Building' in celebration of the ending of the East India Company's monopoly on trade in India and the Far East. This now opened up that part of the world to greater trading opportunities. The Holt family had taken advantage of this, expanding their mercantile marine interests and creating new shipping lines, including the Holt, Ocean Steam Ship Co., and the Blue Funnel lines.

George's three sons, Alfred, Philip, and George, all became equally wealthy shipowners and merchants. By the opening decades of the twentieth century they decided to replace their original commercial structure with a brand new, state-of-the-art, exquisitely designed and very much bigger version of the India Building. This would not only provide headquarters for their own company, but would also offer rented office space to other businesses and so generate revenue.

C

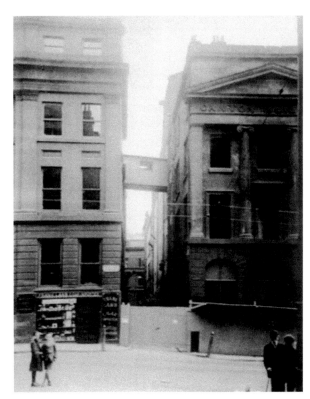

Right: The original Chorley Street, shown in 1923, before work began on the new India Buildings. (Athenaeum Library)

Below: Modern India Buildings dominating Water Street. (DL Library)

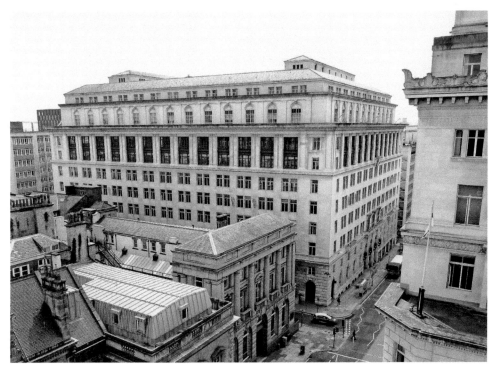

The Holts commissioned Liverpool-born architect Herbert J. Rowse (1887–1963) to design it. The son of a builder, Rowse studied at Liverpool School of Architecture and, while he created major buildings for other cities, he is best known for his work in Liverpool, much of which is referenced in this book. The Holts' new headquarters was the architect's first significant commission and it launched his career. However, this was something of a commercial gamble for the shipping family, who instructed the young man to design the building in such a way that, if necessary, it could be rapidly transformed into a warehouse if the rentable office space should lie vacant.

Rowse began work on clearing the ground for his streamlined, art deco design, and it would take from 1924 to 1932 to complete at a cost of £1.25 million. However, as part of his plan, Rowse intended to completely demolish Chorley Street and construct his new building right across the old road. Unfortunately, Liverpool Corporation refused permission, so the architect had to find a creative solution to this problem.

He did so by creating a beautiful, barrel-vaulted shopping arcade running right through the centre of his building, which he named 'Holt's Arcade'. This now met the corporation's requirement to keep a thoroughfare on the site, and provided office

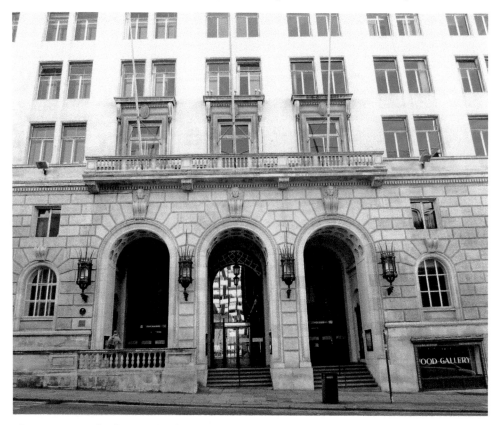

The entrance to the former Chorley Street. (DL Library)

workers and pedestrians alike with access to a range of new shops. While one or two occupants of Chorley Street were happy to rent office space in the new building, others found the fees too high. Nor could they afford to rent space in the new shopping mall. However, other traders and shopkeepers were attracted to the stylish new retail venue and moved into Holt's Arcade and so, by default, into Chorley Street.

Although both ends of the Arcade were originally open to the elements, the wind whistling through from the river soon encouraged the corporation to allow Rowse to put great glass doors on either end, and these remain to this day, as does Chorley Street. This is because the thoroughfare has never officially been removed from the original Post Office address list. Even though it does not appear on any modern street maps, and if you posted a letter to Chorley Street there is no saying where it would actually end up, Chorley Street remains a road in disguise.

Incidentally, India Building, and its Arcade, was burnt out during German air raids during the Second World War, when Liverpool was the most heavily bombed city in Britain outside London. After the war, Rowse completely redesigned, rebuilt, and restored it using his original plans.

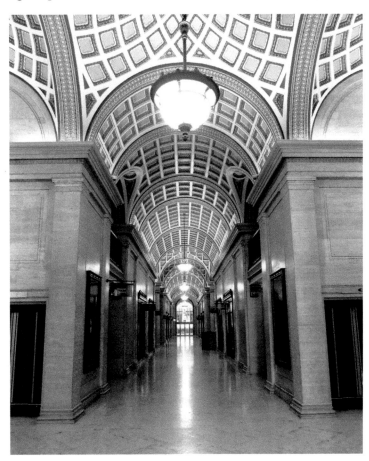

The modern Holt's Arcade, but still Chorley Street. (DL Library)

Duke of Wellington's Column

In what is now known as Liverpool's St George's Quarter is found one of the finest collections of neoclassical structures in Europe, dominated by the magnificent St George's Hall (1854). The other buildings are the Liverpool Central Libraries (1860, restored in 2013), the Walker Art Gallery (1877), and the County Sessions House (1884). These all stand along William Brown Street. This was named after the wealthy banker who, in the mid-nineteenth century, gave the money to build another of these stunning civic and cultural structures, Liverpool Museum (1860), now renamed The World Museum, Liverpool.

At the head of the street and the top of a hill, directly facing the mouth of the Queensway Mersey Tunnel at the bottom of the road, stand two classic monuments.

One of these is the Steble Fountain, which was built in 1879 and is made entirely of cast iron. It is named after Lt-Col. Richard Fell Steble, who was the mayor of Liverpool from 1845 to 1847, and who gave the fountain to the city. The other is the historically important and visually imposing Duke of Wellington Memorial Column, otherwise known as the 'Iron Duke's Column' because of the great commander's most popular public nickname. His other common nickname, especially among his troops but always used with affection, was 'Conky Bill', because of his great, hooked nose!

The column is mounted on a stepped plinth and was erected as a tribute to Arthur Wellesley, the 1st Duke of Wellington (1769–1852), who was one of Britain's greatest national heroes. This was particularly because of his victory over the French Emperor Napoleon Bonaparte (1769–1821) at the Battle of Waterloo, which was fought in 1815 in what is now Belgium.

Named the 'Iron Duke' because of his determination and formidable resolve, the people of Liverpool wished to honour the memory of this outstanding military leader, who had been prime minister of Britain from 1823 to 1830, and again in 1834. He was also a trusted advisor of a young Queen Victoria (1819–1901).

The fluted column was designed by Andrew Lawson from Glasgow and its foundation stone was laid in 1861. The monument was formally unveiled on 16 May 1863, in front of an appreciative and enthusiastic crowd of thousands of people. As the Iron Duke's statue was revealed, a salvo was fired from nineteen cannons, followed by a band playing 'Hail the Conquering Hero Comes'.

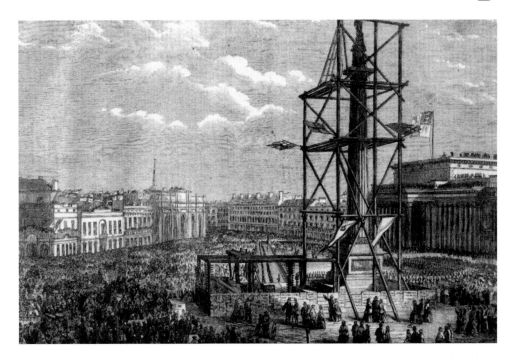

Above: The formal unveiling of the Duke of Wellington's Column. (Athenaeum Library)

Right: The Wellington Monument standing proudly at the head of William Brown Street, in the St George's Quarter of Liverpool. (DL Library)

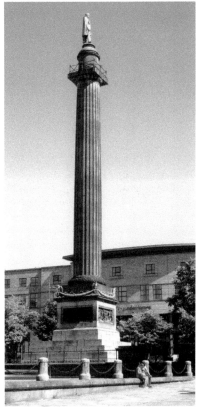

Standing 132 feet high, the Wellington Column was carved from Darleydale stone and supports a bronze statue of the duke. This figure was designed by Andrew Lawson's brother George and is 14 feet high. It is cast in metal melted down from cannon captured from the French at Waterloo. The statue is positioned facing south-east so that Wellington would always be looking towards the site of his greatest victory.

A brass panel relief at the base of the column shows the final charge at Waterloo, and the duke can be seen mounted on his horse, telescope in hand, commanding the advance against the enemy. On the east and west faces of the pedestal other panels, mounted in 1865, list all the names of the duke's victorious battles. The east panel records Assaye, Talavera, Argaum, Busaco, Rolica, Fuentes de Onoro, Vimeiro, Cuidad Rodrigo, Oporto, and Badajoz; and the west panel the battles of Salamanca, Bayonne, Vittoria, Orthez, San Sebastian, Toulouse, Nivelle, Quatre Bras, and Waterloo.

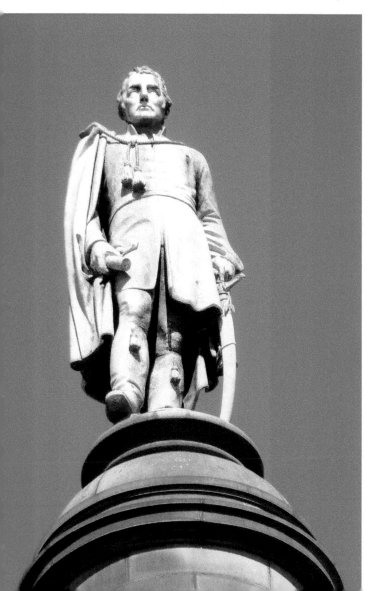

The 'Iron Duke', cast in bronze from captured French cannon, gazes out towards Waterloo. (DL Library)

The column is, in fact, a hollow cylinder, inside which a spiral stone staircase of 169 steps travels up to a viewing platform below the duke. Though cemented onto the column, the statue is secured in place by a thick steel cable that is kept under tension and anchored at the base of the monument. Also, a recently rediscovered tunnel leads from the basement of St George's Hall, under Lime Street, directly to a cellar beneath the column, which then gives access to the steps to the top.

Another curious feature is what is set into the base of the column's plinth and pavement. These are the pre-metric, imperial standard Board of Trade measurements of length at 62 degrees Fahrenheit. The shorter ones – at 1 inch, 1 foot, and 1 yard – are mounted onto a bronze panel fixed to an adjacent wall. From this, set into the pavement and running parallel with the nearby Walker Art Gallery, is set a long brass strip. This shows the larger measures of 100 feet, and of a chain of a 100 links.

The Wellington Column fits in perfectly with the other statuary, monuments, and buildings that together make up the St George's Quarter. This whole area of the city centre reveals just how the mid-Victorian leaders of Liverpool regarded their town as a 'New Rome' and themselves as latter-day classical senators.

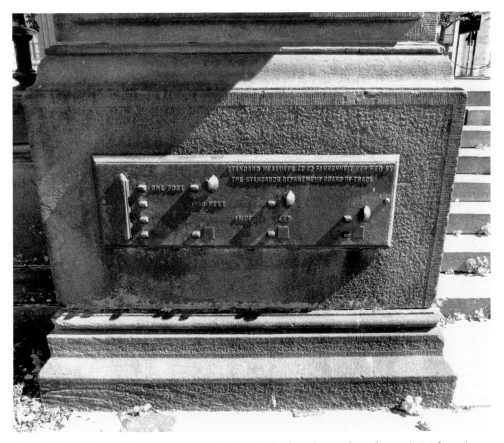

Some of the old imperial measurements that are to be found near the column. (DL Library)

Epstein Theatre – Small, but Perfectly Formed

On the corner of School Lane and Hanover Street stands the Epstein Theatre. This is part of the five-storey building that was originally built by the Crane Brothers for their prestigious music store and offices.

They had been trading for several years when, in 1913, they opened Crane's Music Hall on the second floor above their store. This was not a music hall in the Victorian variety theatre sense; in fact, this was a commercial venture designed principally to promote the sales of their musical instruments. Classical concerts and recitals were presented here, featuring accomplished professional musicians who made playing look so easy that, after the performances, audiences would immediately place orders for violins, cellos, clarinets, and pianos!

The auditorium of the music hall was constructed with 445 seats, set in slightly concave rows on two levels, and facing a fully equipped, traditional, proscenium-arched stage. Because of this layout, and as the venue was quite small, the acoustics for music and speech were excellent. Indeed, after the first year or so, the Cranes realised that the music hall was a business opportunity in its own right, and so they invited amateur drama groups to stage productions here, soon followed by professional theatrical companies. This led to the music hall being renamed as the Crane Theatre in 1938.

From this time, and with the music store thriving on the floors below, a whole range of plays, musical dramas, concerts, and recitals were presented at the theatre, which, over the next twenty years, became a very popular venue. It was also quite a profitable business venture for the Crane family and, in 1960, they added a licensed bar to the theatre's facilities. This was the only alteration that had been made to the music hall since it had become the Crane Theatre, but during the 1960s everything changed for the theatre.

Just as with cinemas, theatre audiences began to decrease with the advent of cheaper and more readily available television sets. Also, small venues like the Crane Theatre could not compete with Liverpool's few surviving larger theatres such as the Empire,

the Royal Court, and the Playhouse. Indeed, these venues were also in financial difficulty. Then, in 1966, Cranes found that they could no longer afford to maintain the theatre, and their musical instrument business was also in decline, so they announced their decision to close their business. However, the history of the theatre, its attractive design, and its particular intimacy appealed to Liverpool City Council and in 1967 they bought it from the family. The council's plan was to create a 'community theatre; run by local people to provide entertainment for local people'. At the same time, and to reflect Liverpool's nautical associations, the theatre was renamed the Neptune Theatre, after the god of the seas who appears in the city coat of arms.

This project began well but, by the end of the 1970s and into the 1980s, plays and concerts were attracting very unpredictable audience numbers and even the council were having trouble keeping the Neptune profitable. They considered closing it.

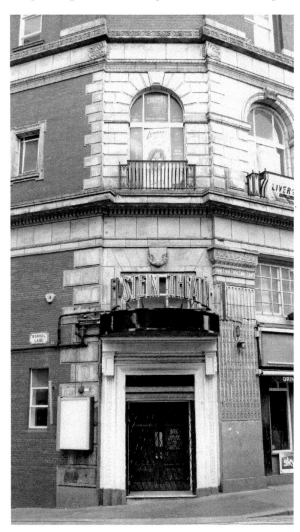

The Epstein Theatre, formerly the Neptune, originally Crane's Music Hall. (DL Library)

However, in the 1990s the theatre seemed to get a new lease of life. This followed a change of management and a more innovative approach to how the Neptune should be used. By the end of that decade it had become particularly well known for showcasing new local comedy talent, such as Terry Titter (Terry Kilkelly) and Lily Savage (Paul O'Grady), and also top-rank stand-up comedians including Lenny Henry and Steve Coogan. It also began to stage more fringe and minority-appeal productions and soon audience numbers began to climb. More often than not the theatre was full, as smaller touring companies and popular individual performers found the Neptune to be an ideal venue for their talents.

The council now realised that there was a market for the theatre and that it would be worth serious investment. Consequently, in 2005 the theatre closed to undergo a complete refurbishment, restoration, and modernisation of its facilities. This was completed without destroying the character of the old building, which is now over a century old. However, a series of administrative and financial problems meant that the theatre was not actually reopened until 2012.

In 1997 the Neptune had been dedicated to the memory of Brian Epstein, the late Beatles manager. At its formal and eventual reopening it was now renamed in his honour as the Epstein Theatre.

Brian was born on 19 September 1934, and he grew up in the Childwall suburb of Liverpool. His family were quite wealthy and owned the North of England Music Stores (NEMS) chain. Becoming the group's manager in November 1961, Brian's

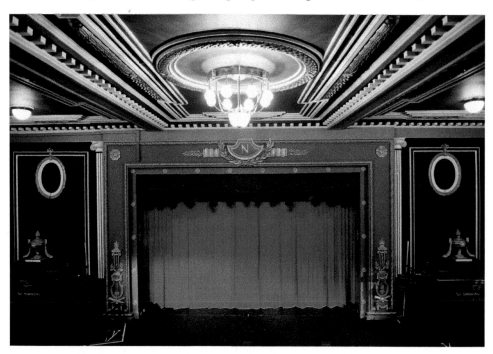

The proscenium of the Epstein, but still bearing the badge of the Neptune. (DL Library)

skills included drive, professionalism, and a special ability to befriend yet lead and motivate the four, young, fiercely independent Liverpool musicians. He undoubtedly transformed John Lennon (1940–80), Paul McCartney (b. 1942), George Harrison (1943–2001), and Ringo Starr (b. 1940) into the world's first international supergroup.

Tragically, Brian died from an accidental overdose of amphetamines, alone in his London flat, on 27 August 1967; he was just three weeks short of his thirty-third birthday.

The Epstein Theatre is a tasteful and fitting tribute to this gifted but ill-fated young man.

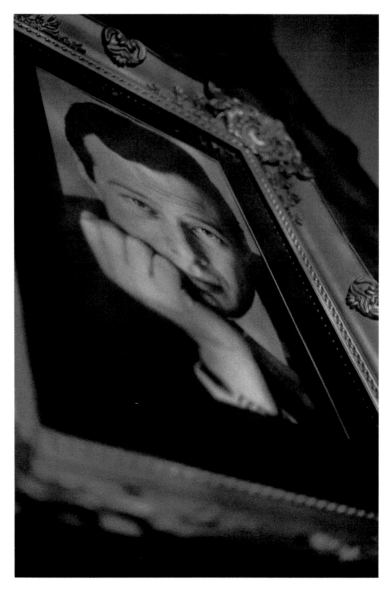

Inside the theatre Brian Epstein's portrait pays tribute to the famous Liverpool impresario. (Epstein Theatre).

Falkner Square – Moss Lake Fields and the Creek

The graceful, tree-lined garden in the centre of Falkner Square remains almost as it was when it was first designed and built, by the family of Edward Falkner, at the end of the eighteenth century.

Falkner had been born in 1760, and he grew up to become a vigorous young man who intended to have a life filled with excitement and experience. He joined the military and was a dedicated and enthusiastic soldier, progressing rapidly up the ranks. After leaving the army, Edward settled to home life in Liverpool and in 1788, at the very young age of twenty-eight, he became Sheriff of Lancashire. He was effective and well respected in this role, but he always remained ready for adventure.

Such an opportunity presented itself when, in 1797, news came that the French were mustering to invade England. Edward sprang into action and, within a day, he had recruited a thousand local fighting men. He equipped and uniformed them largely at his own expense. Very soon they were ready not only to defend Britain but to immediately embark for France and to overwhelm any invasion force that they found there.

When the French government heard what Falkner had done, and in how short a space of time, they took this as a clear indication of British determination and military strength and instantly cancelled their invasion plans. This meant, of course, that Liverpudlians had saved Britain from invading Frenchmen! Falkner became a local and national celebrity, which helped his business interests.

Already a wealthy man, Edward and his family decided to invest in land and property. This was the time when new properties were being built all around this developing residential district, and this presented a speculative opportunity. Falkner commissioned an architect and he designed and built Falkner Square, which Edward originally intended to name Wellington Square. However, the townspeople of Liverpool dubbed it 'Falkner's Folly', because the land he bought was known as Moss Lake Fields.

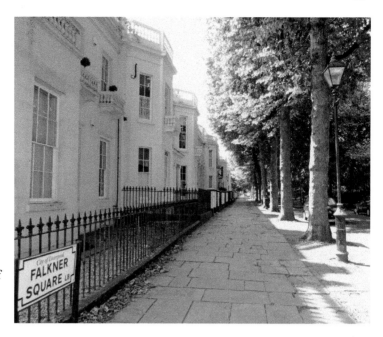

Falkner Square nestles at the heart of Liverpool's stunning Georgian Quarter. (DL Library)

From here, and beneath the marshy surface of the land, lake waters drained to form the broad creek that flowed down Smithdown Lane and parts of Edge Hill, through what would become the university district, on to Pembroke Place and London Road. It then wound its way down to run along what are now Byrom Street, Old Haymarket, Whitechapel and Paradise Street. From here, what had by now become a wide, fast-flowing river fed into the great pool of Liverpool. All of this water still flows down from the modern Georgian Quarter to the Mersey, it is just that it does so underneath Liverpool's streets and buildings, as well as beneath the Liverpool ONE retail district and the docks.

So, for some years many of Falkner's well-appointed new houses remained empty. This was because prospective buyers felt sure that any houses built there would inevitably sink into the marshy ground. Also, this whole area was considered to be too far out of town, and so impractical to live in, or to conduct business from.

Nevertheless, Falkner was undaunted and he drained part of the land. He also redirected and culverted the creek. Not one of his buildings sank – even partially. Nor did they show any signs of subsidence and they never have. In due course the whole area became extremely fashionable and desirable. The Square was particularly so because of its enclosed garden.

This had been included by Falkner in his design as a 'key garden', which was only available to residents of the Square. They each had a key to the gates that excluded the general public from the delightful trees and garden that Falkner had planted there. However, in 1835 the garden was bought by Liverpool Corporation and opened up to the public. Falkner Square remained a comfortable community until the Second World War, when its garden was commandeered as a location for public air-raid shelters.

The Square, and Falkner Street that runs alongside it, were fully reinstated after the war, and are part of Liverpool's Georgian Quarter. This is so named because, during this architectural period, other broad streets of grand terraced mansions were built, including Huskisson Street and Canning Street. These are deliberately and carefully maintained, especially Canning and Falkner streets. Here, the City Council has restored the cobbles, the lamp posts and other street furniture, and encouraged local property owners to do the same to their buildings. This is why these streets, like so many others in this area, are now regularly used as locations for film and television productions. Indeed, Liverpool is the most filmed British city outside London and is considered by film producers to be the second most film-friendly city in the world, after New York.

This is because of the work of the Liverpool Film Office, in partnership with Merseyside Police and Liverpool City Council, who work to make it as easy and practical as possible to film here. It is rare indeed not to see a film or TV crew at work somewhere in the city, especially in the Georgian Quarter of Liverpool, and particularly around delightful Falkner Square.

Elegant and tranquil, the Square no longer reveals that this was once the source of Liverpool's great 'creek' and the ancient 'pool', which had given the town its name and existence. (DL Library)

G

Gog and Magog – The Stone Giants

Adjoining what is now Calderstones Park, once stood Harthill House. This was built around 1825 by Stanley Orred Perceval, who was a relative of Spencer Perceval MP (1762–1812). He was the only British prime minister to have been assassinated, and he was murdered, in 1812, by John Bellingham (1769–1812), who lived in Duke Street in Liverpool.

In 1848 Harthill House was bought by shipping line owner John Bibby (1810–83), and he moved here with his first wife, Fanny. She was the daughter of the great dock engineer Jesse Hartley (1780–1860), who built so much of Liverpool's dock system. After the death of the gifted engineer in 1860, a tall granite obelisk was relocated from the Hartley family home to Harthill, as a tribute to Fanny's father. The obelisk can still be seen in the grounds of the park.

Harthill House was a magnificent building, and was a happy family home until Fanny's tragically early death. John Bibby's second wife, Emily, continued to live at Harthill after her husband's own death, in 1883, until she too died, in 1899.

For a few years the mansion remained a private residence until it and the estate were sold as a possible building development site. However, in 1913 the property was acquired by the City Council, and for a time it was used as the local police headquarters. Indeed, the stables for the horses of Merseyside Mounted Police are still located here.

Unfortunately, during the mid-1930s Harthill House began to fall into disrepair and it was found to be badly affected by dry rot. In 1937 the building was demolished. Nevertheless, and to the council's credit, the estate was retained intact and joined with the neighbouring Calderstones Park to create Calderstones and Harthill Park.

Apart from the quaint lodge house nearby, the gates and walls that now stand at the corner of Calderstones and Harthill roads are all that now remain of Harthill House. These once formed part of one of the entrances to the Harthill Estate, but the large carved stone figures that decorate them are not original.

The corporation relocated the statues here in 1928, from their original site in Water Street in the city centre, and mounted them on the gateposts and walls. The figures once adorned Brown's Buildings, which were owned by the very wealthy banker Sir William Brown (1784–1864), but these were demolished to make way for the Barclays Bank that

now stands on the site. The figures comprise two atlantes, sometimes referred to as Gog and Magog after the legendary ancient British giant Gogmagog. Also, on the walls stand the large but partially weathered sculptures of the Four Seasons.

The site of Harthill House became the city's magnificent Botanic Gardens in 1964. These replaced those that had stood in Botanic Park in Edge Hill until they were destroyed by German bombs in 1940. Sadly, most of the greenhouses of the new Botanic Gardens were also wantonly destroyed. This was during the 1980s, in one of the former militant deputy council leader, Derek Hatton's (b. 1948), acts of civic vandalism. However, one or two do remain, and it is in one such glass conservatory that the Calder Stones are to be found. These are the 7,000-year-old remains of a Neolithic chieftain's burial tumulus, and are the oldest relics in the city. However, their story is not for this book.

The great, naked-torsoed, Herculean figures of Gog and Magog that appear to be supporting the gateposts to Harthill Park are impressive indeed. They gaze down in implacable, dominating, nineteenth-century neoclassical masculinity – a symbol of a bygone age of long-demolished merchant palaces and mansion houses. These, and the graceful stone maidens, add charm and elegance to this corner of suburban south Liverpool.

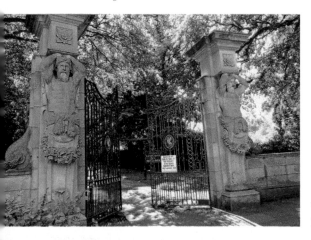

The atlantes that are known as 'Gog and Magog'. (DL Library)

The Four Seasons, who also stand sentinel at the boundary of the former Harthill House Estate. (DL Library)

Hillsborough Memorial

Liverpudlians are emotional people. We are caring and warm and are known for our wit and our sense of humour. We are passionate and are not afraid to share our feelings and our opinions with anyone and everyone, whether invited to or not! There is a unifying sense of community in the city, which crosses the boundaries of religion, politics, and income. This is seen at its best when the city is in genuine crisis, and the Great Depression, the war, the 1960s industrial decline, the Toxteth Riots, and the 2009 recession have all brought us closer together. And so too did the Hillsborough Disaster, but in a way that also deeply scarred us.

This catastrophe saw the deaths of ninety-six football supporters, many of them young people and children. They were crushed to death at the FA Cup semi-final between Liverpool and Nottingham Forest, at Sheffield Wednesday's Hillsborough Stadium. Police and stadium officials allowed around 3,000 fans to be funnelled into a penned-in stand designed to accommodate only 1,600 people. This entirely avoidable tragedy occurred on 15 April 1989, and the youngest victim was a boy of only ten years of age. As well as those killed, 766 people were injured, many of these being permanently disabled, and so the suffering from Hillsborough continues on many levels.

All of this misery and suffering was caused directly by mismanagement of the ground by the host football club and inefficient communication between the emergency services. Principally, however, the fault lay with incompetent and inept police leadership, in particular that of relatively senior officers.

On the day and in the immediate aftermath, as well as for years afterwards, the police, sections of the media, and members of successive governments blamed the football fans themselves for causing the disaster. *The Sun* newspaper in particular repeatedly and falsely accused Liverpool supporters of drunkenness, vandalism, and of looting and urinating on the dead and dying at Hillsborough. This was misinformation deliberately fed to them by the police, which they did not investigate for accuracy and were happy to repeatedly recycle. Consequently, *The Sun* newspaper still has its lowest sales of anywhere in the country here on Merseyside.

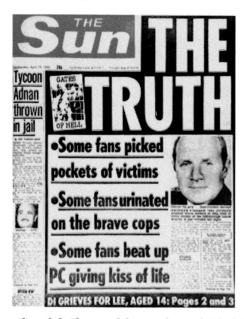

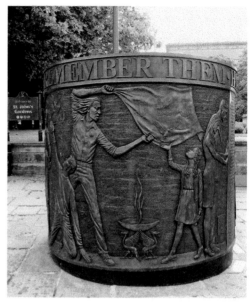

Above left: The scandalous and completely fabricated headline. (DL Library)

Above right: The Hillsborough memorial sculpture near St John's Gardens in the city. (DL Library)

An inquest was held between 1989 and 1991, but the evidence presented was inadequate, misleading, and, in many instances, largely false. The verdict of the coroner (there was no jury) was one of accidental death for all victims, despite extensive witness testimony to the contrary. This outraged the victims' families and incensed the people of Liverpool, and was followed by years of bitter and largely fruitless campaigning for truth and justice.

Eventually, and following a heartbreaking and exhausting campaign led by bereaved families and survivors for over twenty years, in 2012 the High Court quashed the original accidental death verdicts and ordered that new inquests be conducted, this time before a jury. The second Hillsborough inquests, held in Warrington, began on 31 March 2014 and, over two years later, on 26 April 2016, the jury returned a verdict of unlawful killing in the case of all ninety-six supporters.

What the people of the city had always known, but was only confirmed during the inquests, was that rank and file police officers had been ordered by their own officers to falsify their notes of the day to shift blame onto the fans and victims. The evidence of culpability on the part of the police was staggering. Even the most senior police officers had continued to blame supporters and had lied in evidence to hide their own responsibility for the totally preventable loss of life. It had taken over twenty-five years for the truth to begin to come out and, during that time, not only the families of those killed but the people of Liverpool and Merseyside had shared a very particular form of grief and anger.

The Hillsborough Memorial at Liverpool's football stadium, in its new position on 96 Avenue.
(DL Library)

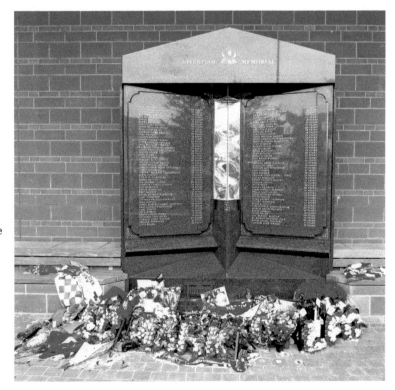

The eternal flame burns between the lists of names of those who were unlawfully killed at Hillsborough. So many of them were young people, and a few were only children.
(DL Library)

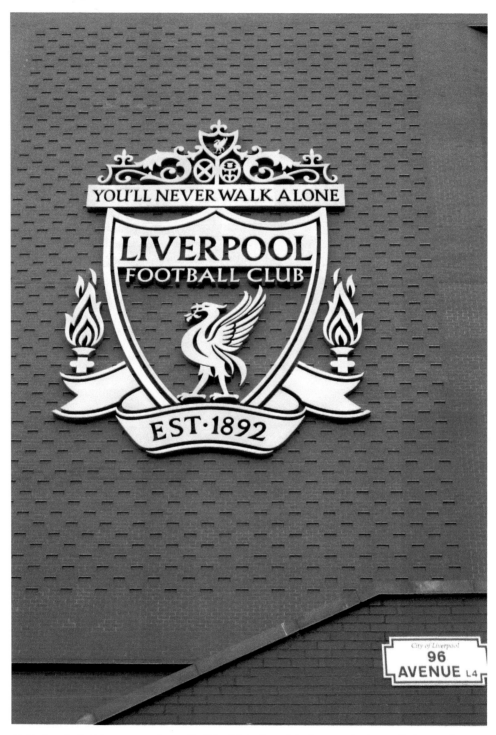

At the head of 96 Avenue, on the wall of the Main Stand, is the massive logo of Liverpool Football Club, with its world-famous motto – 'You'll Never Walk Alone.' (DL Library)

In answer to the specific question posed by the coroner in Warrington, 'Was there any behaviour on the part of the football supporters which caused or contributed to the dangerous situation at the Leppings Lane turnstiles?', the jury returned a clear verdict of 'No'. The relief and vindication was greeted with applause but also with dignity in the courtroom, and also across Liverpool and Merseyside.

On Friday 15 April 2016, the 27th anniversary of the Hillsborough disaster, what is expected to be the last ever memorial service, was held at Liverpool FC's Anfield Stadium, only eleven days before the inquest verdicts were returned.

There are a number of memorials to Hillsborough victims in various places in Liverpool, including simple ones on the west terrace of the Anglican Cathedral and in the garden of Sudley House in Mossley Hill. Also, on the eve of the 24th Anniversary of the disaster, an impressive, large, drum-shaped bronze monument was unveiled at Old Haymarket, adjacent to St John's Gardens. Encircled by a series of relief sculptures, all designed by local artist Tom Murphy and including a complete list of all ninety-six names, this memorial attracts many visitors and many tributes. However, the most poignant and significant memorial is at Liverpool FC's Stadium at Anfield. Here, an eternal flame burns at the heart of the monument, which also bears the name and age of each victim.

Carved in polished red marble, this was originally erected in 1990, adjacent to the Bill Shankly Memorial Gates. This was resited in 2016, to a position on the magnificently rebuilt main stand at the stadium. It stands against the wall, halfway between the centre of the new stand and the Anfield Road end of the ground, on a new roadway named 96 Avenue.

This tragedy is still significant in the hearts of so many people in the city, even those who only watched the horror unfold on television, or who laid flowers on the Anfield pitch in the days after the deaths, or who have supported the campaign of the families. While the victims have been vindicated, the people who caused their unnecessary and brutal deaths may yet escape justice – we wait and watch.

In the meantime, it is important that people of compassion and concern, whether football fans or not, whether from Liverpool or not, make a pilgrimage to the Hillsborough Memorial at Anfield, just to pay a silent tribute to those who lost their lives on that dreadful day in 1989.

Indian Mutiny Memorial Cross

At the time Liverpool was founded, the surrounding area was dotted with villages and townships that had existed long before the new town: such communities as Walton, Kirkdale, West Derby, Childwall, Wavertree, and Woolton. As Liverpool grew and its boundaries expanded, in the late nineteenth and early twentieth centuries, these places were absorbed into the great conurbation to become its modern districts and suburbs – the lost villages of Liverpool.

Another such community is Everton, and its name derives from the Romano-British name Evoracum, meaning 'place of the wild boar'. On the edge of this district is a large area of attractive public parkland named Whitley Gardens. This is named after Edward Ewart Whitley (1825–92), a Conservative MP for Liverpool who also served a term as lord mayor.

The parkland faces onto Shaw Street and is adjacent to the stately apartment complex that was once the Collegiate Grammar School. Famous past pupils of this prestigious school include the Beatles former drummer Pete Best; local DJ and broadcaster Billy Butler; Holly Johnson, lead singer with Frankie Goes To Hollywood; footballer Brian Labone; comedian Ted Ray; and actor Leonard Rossiter.

Whitley Gardens is a delightful area for a stroll, and beneath a long row of aged trees, and almost hidden beneath the sheltering canopy of their leaves and branches, is the tall, imposing, weathered Indian Mutiny Memorial Cross.

This is mounted on a bulky sandstone plinth and commemorates 243 private soldiers, officers, and non-commissioned officers from the 8th Kings Regiment Liverpool. These were men who died during a rebellion amongst Indian soldiers during the mid-nineteenth-century Great Sepoy Rebellion. On the base an inscription explains that the monument was originally erected at Portsmouth in 1863, was then moved to Chelsea in 1877, and finally came to Liverpool in 1911.

The extremely violent and bloodthirsty outbreak of protracted violence marked by the cross took place in the Indian city of Meerut, in the state of Uttar Pradesh, in 1857. The rebellion raged across north and central India for more than a year, and was the result of a long period of resentment on the part of native Indian soldiers, known as Sepoys, against their British officers and imperial overlords.

The Indian Mutiny Memorial Cross in Whitely Gardens in Everton. (DL Library)

However, the trigger was the introduction of the Enfield rifled musket. This fired cartridges that, during manufacture, had been greased with pig and cow fat to enable them to travel smoothly down a rifle barrel. To load the rifle the Sepoys had to bite the cartridge open to release the powder. This caused them deep religious offence because many were Hindu and so could not touch anything from cows, an animal they hold as sacred. The rest of the soldiers were Muslim, and so they could not touch anything from pigs, which they regard as unclean.

British officers failed to take seriously the level to which their troops were offended and insulted by their orders to bite off the end of the cartridges. When, on 24 April 1857, ninety Sepoys were imprisoned for refusing to obey this order, discontent spread rapidly throughout the ranks. On the 10 May a large number of Sepoys mutinied and forcibly released their imprisoned compatriots, killing all the Europeans in the process. They then marched on the city of Delhi, which they occupied.

The rebels gained increasing and considerable support, and occupied much territory as they massacred more Europeans in one town after another. These included Lucknow, Cawnpore (now Kanpur) and Jhansi. Here, the rebels committed a series of massacres of women and children that particularly outraged the British public and prompted fierce reprisals by the British Army. Nevertheless, it was not until the end of 1858 that the rebellion was finally suppressed, which involved the British razing many Indian villages and executing their entire populations. The Indian people named this 'The Devil's Wind', and it has been described as 'the most brutal moment in British imperial history'.

There are a number of pictorial carvings on the shaft of the Memorial Cross but as these are so worn by age and weather it is difficult to make them out clearly. However,

they undoubtedly show scenes of the commemorated British soldiers in action against the Indian rebels.

The monument marks what is now a lesser-known part of British history, but one that reflects very badly on our national history and on colonialism generally. Nevertheless, it particularly honours Liverpool-born soldiers who died during the mutiny, and their names are also listed, although these are particularly badly worn.

Nevertheless, the main inscription can just be made out and it reads as follows:

> This Cross commemorates the services and death of 243 Officers, N.C. Officers, and Private Soldiers lost by the 8th The Kings Regiment, while engaged in suppressing the Great Sepoy Mutiny of 1857–8. Some died in battle, some of wounds, some of disease, all in the devoted performance of duty.

In 1863, another memorial to British Army losses during the rebellion was erected by the British government in India, near the Kashmiri Gate in New Delhi. In 1972, on the 25th anniversary of Indian independence from British rule, the Indian government renamed the memorial 'Ajitgarh' or 'Place of the Unvanquished'. They also raised a plaque explaining that the 'enemy' referred to on the monument were 'immortal martyrs for Indian freedom' – one man's terrorist is another man's freedom fighter.

The monument is very badly weathered, but it is just possible to make out some of the images. (DL Library)

J

John Hays Wilson Gazebo – Floods and Gargoyles

Another of Liverpool's lost villages is Little Woolton, now known as Gateacre, and this charming Georgian and Victorian mock-Tudor village has kept most of its features as well as its identity.

In the centre of Gateacre Village Green, at the heart of this small community, stands a handsome sandstone gazebo. This once housed a commemorative water fountain and it was erected, in 1883, as a memorial to a local resident of nearby Lee Hall (now demolished) by the name of John Hays Wilson, who was born in 1825.

Wilson was a wealthy brass founder and industrialist who served on the local authority as chairman of Liverpool's Water Committee. One of his most significant responsibilities was to drive forward and oversee the design and planning of a new fresh water pipeline. This would transport water from the hills and valleys of North Wales to the rapidly expanding and increasingly thirsty population of Liverpool.

This development was crucial in improving the public health of the city, as it now made available cheaper fresh, filtered, pure water. This helped prevent the lethal outbreaks of cholera, typhoid, dysentery and diarrhoea that had so afflicted especially the poorer people of Liverpool for so long. Construction work on a dam and reservoir began in Wales in 1881, and was finished in 1888. This was the first of its kind in the world and was built partly from great blocks of Welsh granite. Sadly though, Wilson did not live to see his revolutionary idea completed as he died in 1881, having caught a chill at a horseracing meeting held in the grounds of his home.

The new reservoir, now named Lake Vyrnwy, flooded the head of the River Vyrnwy Valley and submerged the small village of Llanwddyn. Indeed, at times of drought the rooftops of some of the cottages can still be seen above the water level. Thirty-seven houses were inundated by the new lake, as well as ten farmhouses, the church and two chapels, and three pubs. However, before the old Llanwddyn disappeared, Liverpool Corporation built an entirely new one further down the valley. Even the bodies from the churchyard were given a new home!

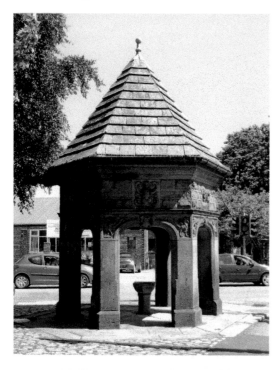

The John Hays Wilson Gazebo sits at the edge of the village green in delightful Gateacre. (DL Library)

This image of a dragon is just one of many reliefs cut into the sandstone of the memorial fountain. (DL Library)

Today, Lake Vyrnwy is a very popular tourist destination, and its waters cover an average width of half a mile (0.80 km) and a length of 4.75 miles (7.64 km). It has been designated a nature reserve and the RSPB has a number of bird hides around its shores.

It was the villagers of Gateacre who raised the funds to build the memorial to John Hays Wilson, and it is adorned with some very strange and finely carved figures. These include a variety of animals, most seemingly mythical, including mermaids playing musical instruments and a Liver bird. Also, you will find a very large, gruesome, but unidentifiable gargoyle creature that appears to be jumping out from one side.

No one is quite sure what this clearly mythical creature actually is, as it leaps out dramatically from the corner of the gazebo. (DL Library)

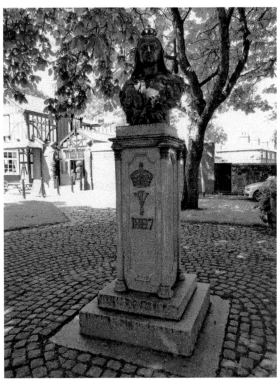

Under the shade of the trees the Old Queen sits, perhaps longing for the days when local children used to give her a birthday 'wash and brush up'! (DL Library)

Near the gazebo on the green, and standing directly in front of the gloriously half-timbered Black Bull pub, is a bronze bust of Queen Victoria mounted on a tall pedestal. This was placed here in 1887 as a donation from Sir Andrew Barclay Walker (1824–93), of brewing fame, and who also gave the Walker Art Gallery to the city. The bust was restored some years ago and, in what was once an annual tradition on her birthday, local children ceremoniously washed and waxed the old queen's bust amid much fun and frolic. This is not allowed nowadays though!

King John's Hunting Lodge

As we saw in chapter one, in 1207 King John made the great tidal pool of 'Leverpul' the harbour for his conquest of Ireland. He was also drawn here by the vast area of forested land that lay between what is now Parliament Street and Queens Dock, and Aigburth Vale, and that stretched from the river to Smithdown Road at Wavertree. This was listed in the Domesday Book as the Anglo-Saxon and Viking territory of Stochestede Forest, but we now know it as the district of Toxteth.

John valued the 2,000 or more acres of the forest, not only because of the hundreds of trees he could fell to build his fleet of warships, but because of the large number of game animals and birds that thrived there. These included red and fallow deer, wild boar, hare, pheasant and partridge, so the king declared the forest to be his own private hunting reserve. John went hunting in Toxteth with his knights and courtiers.

The gates to what was once King John's upper lodge house, with the date of the founding of Liverpool, and the liver birds boldly mounted on them. (DL Library)

There were also wolves in the district, so the king entirely enclosed his forest with palings and then stone walls, 5 miles in circumference. This was not only to keep out these predators but local people as well. John also employed a master huntsman and forty-nine wardens to police the park and to prevent poaching. To aid them in their game keeping the wardens had ten horses, two packs of dogs, and fifty-two spaniels.

There were two lodges for these wardens: one on the edges of what is now Sefton Park, known as 'Higher Lodge', and one at Aigburth, known as 'Lower' or 'Otterspool Lodge. Toxteth Forest remained a royal preserve until 1426, when Henry VI (1421–71) granted it to local aristocrat Lord Thomas Stanley (1435–1504). He would go on to be ennobled as the 1st Earl of Derby by Henry VII (1457–1509), as a reward for switching sides during the Battle of Bosworth in 1485, thus forcing the defeat and murder of the tragic Richard III (1452–85).

Then, in 1446, the king awarded the master forestership of all the royal forests and parks, including Toxteth, to Sir Richard Molyneux (1422–59), whose descendants would go on to become the Earls of Sefton.

King John's Lower Lodge was pulled down around 1863, when the Cheshire Lines Railway was laid through Otterspool, and a nearby station was opened in 1864. Only some large stones survive from this ancient lodge. However, parts of King John's Higher Lodge do survive, although these now form part of the core of a private house.

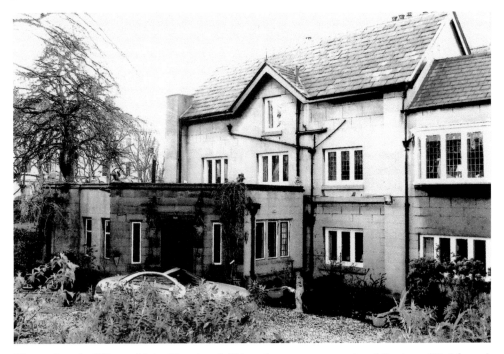

The modern building, with its 'Russian doll' interior structures and architecture. (DL Library)

The building is named Park Lodge and this, together with golden silhouettes of liver birds and the letters 'AD 1207', is emblazoned on its tall, heavy metal gates. Behind these and a high encircling stone wall stands a 'Russian doll' of a house set on the corner of Windermere Terrace and Sefton Park Road. This is a continuation of, appropriately, Lodge Lane, near the gates to Liverpool's largest public open space, Sefton Park.

The foundations of Park Lodge are part of the original hunting lodge, but the main part of the house is from the Tudor period. There were then Jacobean additions, followed by some alterations and extensions during the Georgian period. Then the Victorians made their mark on the building, which was again refurbished and restored in the 1920s. During this work, two original Elizabethan fireplaces were uncovered, as well as parts of the original hunting lodge. These included sandstone walls that are 3 feet thick, some wattled walls, secret cupboards, and built-up mullioned windows. This restoration, and the complete redesign of the extensive garden, was another project carried out by Herbert J. Rowse.

The current owner of the house is one of my fellow proprietors of the Athenaeum and, as such, very kindly allowed me to explore her entire property, including grovelling around the foundations with a torch. This was a great privilege as the house is not open to the public. I, therefore, treasure the opportunity I had to discover for myself the remains of one of the buildings created for, and very likely used by on more than one occasion, the monarch who founded my home city.

Some of the dressed stones, found deep in the cellar below the house. These are believed to be remnants of the king's original thirteenth-century hunting lodge. (DL Library)

L

Little Bongs

Just on the outskirts of another of Liverpool's lost villages, Knotty Ash (yes, this is not simply the fanciful creation of the Liverpool comedian Ken Dodd), nestles a very small hamlet. This is completely hidden away from passers-by and, unless you know where it is, you would be hard-pressed to discover Little Bongs. No, this is not a Ken Dodd fantasy either.

On a busy dual carriageway near the new Alder Hey Children's Hospital is an arched entrance between late eighteenth-century cottages. This leads into a short passage and then onto a roughly cobbled and paved path. This leads past some unprepossessing outbuildings, garages and rear yards. However, perseverance pays, because at the end of the path is a wall and the path then becomes much narrower and turns right – this is Little Bongs.

Here, along the remainder of the pathway, you will find two adjacent terraces, each of a dozen or so enchanting old cottages. These are lined up along the right side of the pathway. On the left side of the path, directly opposite the front doors, each cottage has its own area of garden that is narrow but quite long. These are all well maintained

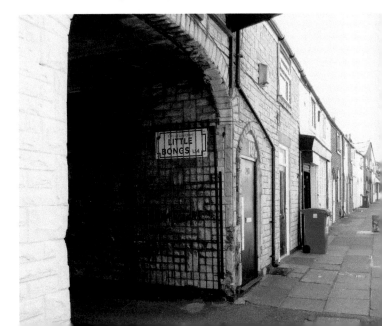

The somewhat unprepossessing entrance to Little Bongs, off East Prescot Road. (DL Library)

with obvious affection. Some are mostly lawn, some have colourful flower beds, and others have tall trees and shrubberies. One or two have gazebos or pergolas and a few have garden seats and tables, but what they all share is that they are charming. Also, most of the front doors have baskets hanging from their porches, each filled with brightly coloured flowers.

No noise penetrates this secluded little hamlet from the very busy roadway so close nearby, all that can be heard is the rustling of the breeze in the trees and the songs of the birds. Perhaps this shows what other parts of this neighbourhood may once have looked like, before the area became so built-up.

The cottages of Little Bongs, as well as those in which the entrance archway is set, were all built two centuries ago by Joseph Jones, a local brewer who also erected and operated the former Knotty Ash Brewery. This was situated further along the cottage row, just past the entrance to Little Bongs.

The name of this petite community might come from either the bungs used in casks of ale, or from an old field name deriving from 'bong', a corruption of 'bank', indicating that the area may once have been a grassy bank. Or, the word might simply be a dialect word for cottages, so 'Little Bongs' might just mean 'small cottages'– no one is certain. This secluded hamlet, though, is not the only such hidden, secret, and ancient community in or near Liverpool, if one knows where to look!

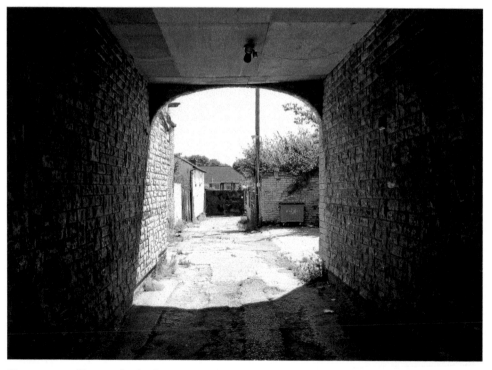

The narrow alleyway leads down to a surprisingly isolated and picturesque community of terraced cottages. (DL Library)

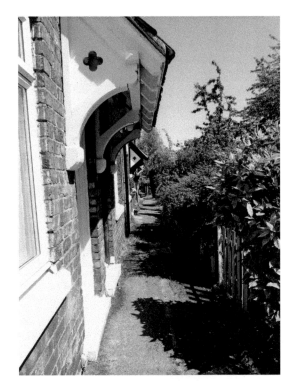

Right: With its narrow pathway, hanging baskets, and individual gardens, this is a truly delightful spot. (DL Library)

Below: One would not think that this hidden community, with its flowers, birdsong, and gentle breezes, is only yards away from one of Liverpool's busiest trunk roads. (DL Library)

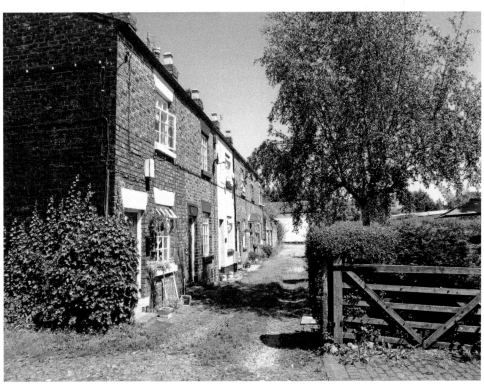

Mount Sion – Close to God

The long, high ridge that dominates the southern edge of the city centre, and upon which the great Anglican Cathedral sits and gazes down upon Liverpool and its river, is now known as St James's Mount. But for centuries this hill was locally known as Mount Sion (Zion). This was because local people said it was 'close to God'.

On its eastern side, the mount and the cathedral overlook a wide, deep cemetery that runs the full length of the hill. This is now named St James's Burial Ground, but this was originally the very large Mount Sion Quarry. Records referring to this go back as far as 1572, but it is undoubtedly far older. Stone from here was used to build many of Liverpool's older buildings as well as, later, the Town Hall and a number of the dock walls of the port. People who worked the quarry or who lived on or near the mount called it Quarry Hill.

Being so exposed to the elements, Mount Sion was exceptionally windy at times and, probably from the early sixteenth century, a windmill had been erected at each end with a narrow, beaten-earth pathway between them. One was where the large Lodge House now stands on Upper Parliament Street. The other was where the neoclassical mortuary temple known as The Oratory now stands, near Upper Duke Street. At this end was a 'house of entertainment' complete with a bowling green, but great mounds of waste and spoil had accumulated around the mount, making the whole hilltop unsightly and unpleasant.

Between 1767 and 1768, unemployment in the town was high and the weather particularly severe. On 7 December 1768 the mayor, Sir Thomas Johnson, instructed the corporation to employ local people to landscape the area of spoil heaps. It is likely that this was one of the town's first 'Job Creation Projects'. As part of this work, the top of the mount was levelled, landscaped, terraced, and planted with trees and shrubs along its full length. These provided shelter from the winds, shade from the summer sun, and secluded areas for gentle promenades and romantic interludes.

The side of the hill that sloped away towards the river was now reformed into a beautiful area of pleasure gardens and winding walkways between the windmills, described at the time as being 'a favourite resort for people in the middle rank of life'. This area was then named Mount Sion Gardens.

A coffee house and tavern were soon built, serving people of 'superior class'. Even the birds liked the mount, because a dense rookery developed in the tall treetops. However, this presented a few hazards, not the least being the noise at roosting times, when the cacophonous cawing of the building of rooks, unkindness of ravens, and the murder of crows became almost deafening. Also, the raining down of guano could change hairstyles and colours of clothes to a considerable extent. Even so, and among other visitors, these pleasure grounds on the mount soon also became a favourite location for nurses and nanny's to take their young charges on outings.

The early eighteenth-century windmill at the northern end of Mount Sion.
(Athenaeum Library)

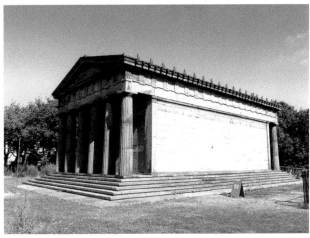

The mortuary chapel, known as The Oratory, was built to service the burials in the deep cemetery, converted from a very ancient quarry.
(DL Library)

In 1774 St James's Church was opened on Parliament Street, the road at the southern end of the mount. It was from this time that the walk became known as St James's Walk. The hill, though, still remained Mount Sion.

In 1841 an observatory was constructed on the mount. This also became the location for Liverpool's first commercial photographic portrait studio, specialising in the daguerreotype process. This was operated by a Mr Spencer of Slater Street, who paid the remarkable sum of £2,500 for the right to take portraits in the town and within a radius of 10 miles.

The views from the mount must then have been spectacular but as the Industrial Revolution took hold and the town grew, the perspective changed: 'The valley below the Walk is covered with chimney shafts, vomiting forth the dense volumes of smoke which hang over it like a sable pall'. The windmill at the Parliament Street end of the mount was blown down in a storm, in 1821, and in its place the present building was constructed as a comfortable lodge house for the gardeners of the pleasure grounds. This was converted into a private residence in 1997.

The quarry continued to expand and deepen during the closing decades of the eighteenth century as the demand for building stone increased, but it had been worked out by 1825. It was then decided to convert it into a cemetery, because as the population grew so did the need for burial space. This meant that a mortuary chapel would be needed. So, on the Upper Duke Street end of the mount, the other windmill was pulled down and, in 1827 The Oratory was built in its place. The cemetery was designed by John Foster Junior (1786–1846), the Corporation surveyor of Liverpool, as was The Oratory. This delightful, classic-revival-style building is a beautiful,

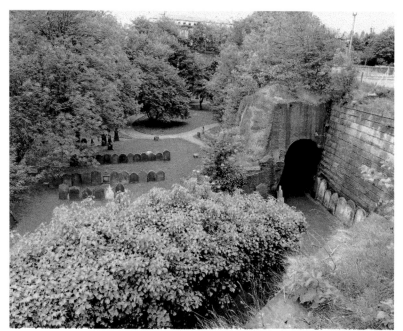

The original quarrymen's cutting in the sandstone rock that gave them access to the stone that built so many of Liverpool's older buildings and docks. Now this is the entranceway into St James's Burial Ground. (DL Library)

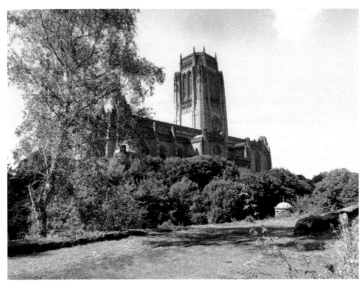

The Anglican Cathedral stands on Mount Sion, now renamed St James's Mount. It watches over the modern gardens, the bodies that lie beneath the ground, the ancient trees and woodlands, and the mysterious legends that still surround the old stoneworkings. (DL Library)

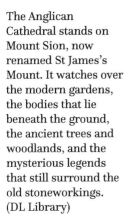

miniature, Greek Doric temple. It still stands on its own equally miniature acropolis overlooking the original quarry entrance tunnel that now became the pedestrian access down into the burial ground.

Horse-drawn hearses and funeral cortèges entered the new burial ground from gateways on Hope Street. These then made their way down a zig-zag of terraces, past rock-cut catacombs for the coffins, or down to the base of the quarry to join the ranks of graves and tombstones that were soon amassing there. Funeral services were held in The Oratory before burials took place, but it was also used as a place for memorials and monuments to the deceased.

By 1936 St James's Burial Ground had reached capacity and contained almost 60,000 corpses, so it was closed. The Oratory fell into disuse and is now managed by National Museums Liverpool (NML). Today, it houses many fine pieces of sculpture and statuary, some by significant nineteenth-century artists.

The cemetery was neglected and left to become completely overgrown. Then, in 1972, work began to clear away the undergrowth and cut back some of the hundreds of trees that had since grown around the graves. All but a few dozen gravestones and table tombs were moved to stand against the walls of the former quarry, leaving space for the great hollow to be landscaped into the glorious, if somewhat macabre, public garden it remains today.

Nelson Memorial – Navies and Nudes

Having already celebrated one great British hero of the Napoleonic Wars in this book, it is only right that we do so with his counterpart, Admiral Horatio Lord Nelson (1758–1805). His own spectacular memorial stands in the centre of Exchange Flags, at the rear of Liverpool Town Hall.

The Exchange was the name for Liverpool's first town hall, built in 1515. This was not only a place for civic administration but, as its name implies, a centre for the buying and selling of commodities, principally wool and cotton. This was such an essential part of Liverpool's economy that hundreds of traders spilled out into the great space to the rear of the town hall. In the late eighteenth century this area was first paved with flagstones, which gave rise to its current name.

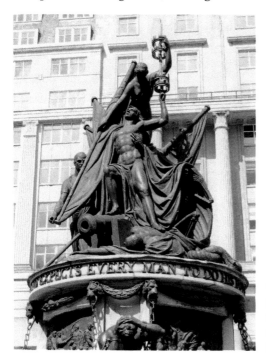

The Apotheosis of Nelson stands as a magnificent tribute to Britain's greatest naval hero. It was the first piece of public sculpture ever erected in Liverpool. (DL Library)

The memorial sculpture group that dominates this large square is dedicated to Nelson, and was the first piece of public sculpture ever erected in the town. It was paid for by public subscription and was unveiled in 1813. Liverpool was one of the first towns to commemorate the death of Admiral Nelson, as he was a great hero to its people, especially its shipowners and merchants. This was because he and his navy not only defeated the French, but because his fleet kept the sea lanes free of other enemy ships and foreign privateers (government-sanctioned pirates). This protected Liverpool's own merchant vessels and privateers, which were the economic lifeblood of the town.

To the grief of the entire nation, Nelson fell at the Battle of Trafalgar in 1805. As the great sailor stood on the deck of his flagship, HMS *Victory*, he was mortally wounded by an enemy sniper's bullet, fired at him from the rigging of a French warship that was sailing at close quarters with *Victory*.

Officially titled the Apotheosis of Nelson, the memorial is a glorious celebration of the man and his legend. It comprises a large bronze group, showing at the top a gloriously naked but discreetly draped Nelson defeating a skeletal death figure. He is transcending into eternity under the guiding hands of the goddess of victory.

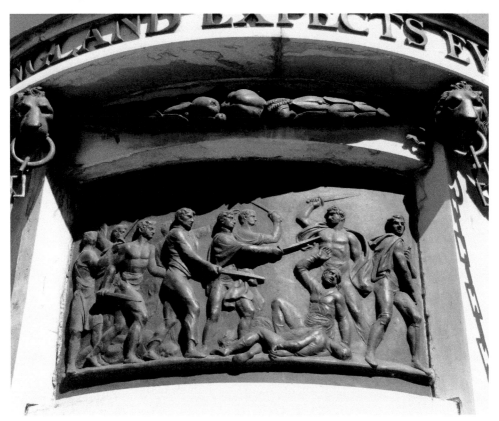

One of the bronze relief panels, depicting one of Nelson's great naval victories. (DL Library)

Not a slave, but a defeated and captive French or Spanish sailor. (DL Library)

The monument also displays four bronze plaques that show scenes from his greatest naval triumphs, at the battles of Cape St Vincent (1797), the Nile at Aboukir Bay (1798), Copenhagen (1801) and, of course, at Trafalgar.

Around the base of the monument sit the naked male figures of four captives held in chains and racked with anguish. These are not slaves, as is often mistakenly believed, but representations of defeated French and Spanish sailors.

Encircling the statue and set into its granite base are the words of Nelson's signal to his fleet at the start of the Battle of Trafalgar: *'England expects that every man shall do his duty'.*

Horatio Nelson certainly did his duty to the nation. During this sea battle the British Navy lost no ships of the line, whilst our enemies – the Spanish and the French – lost all but ten of theirs. The enemy fleets lost 4,408 men, while the British lost only 449.

O

Oak House – 'Diddy' and 'Doddy'

As I have already pointed out, the village of Knotty Ash really does exist and was not simply the invention of its most famous resident, the popular comedian Ken Dodd. It takes its name from a large, ancient, gnarled, and very twisted ash tree that once grew in the village. Sadly though, this succumbed to the ravages of age early in the twentieth century.

Ken was born on 8 November 1927 in Oak House, the home in which he lived all his life and is the oldest building in the village. Built in 1782 as a manor and farmhouse, it is now a listed Georgian building. Naturally, as his private residence, the house has never been open to the public.

Although not a 'Lord of Liverpool', in the sense of the other members of Liverpool's 'official' aristocracy, 'Doddy' (as he was always known locally) nevertheless claimed the title of 'The Squire of Knotty Ash'. This may be more legitimate than it might first appear, as some historians accept that the title of 'Squire' of the village comes with the ownership of Oak House.

The comedian's Great Uncle Jack (John Leech), who was a small man, was affectionately known in and around the village as 'Diddy Jack' the Diddy Man, and this inspired Doddy to create his own cast of cartoon-like comedy characters – the Knotty Ash Diddy Men. Diddy Jack wore a long coat and a bowler hat, and he drove around the streets in his two-wheeled, pony-drawn trap, hardly being seen above the reins. As he rode along, he could be heard singing all the latest music hall songs, and he was a much-loved character in and around Knotty Ash.

Like his uncle, Ken himself became much loved. After leaving the local village primary school, Ken attended Holt High Grammar School in Childwall (my own school incidentally), now called Childwall Sports and Science Academy. He then began his working life as a coalman and then a door-to-door salesman. Ken said that these jobs taught him the skills of conversational banter, making amusing gossip, and using quick-fire humour. This gave him the idea of going into showbusiness. Determined to succeed as an entertainer, he gave up the life of a tradesman and made his professional theatrical debut at the Nottingham Empire in 1954.

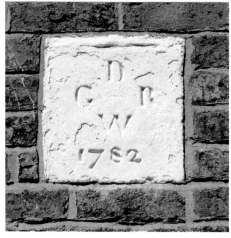

Above: Oak House on the edge of Knotty Ash village. (DL Library)

Left: The date stone of Oak House, reading 1782. This was likely built on the site of a much older manor house. (DL Library)

Ken learned his craft well and began to gain a reputation around the theatres and variety clubs of the North of England. He began his career as a ventriloquist, a skill that he continued to incorporate into his act throughout his career with his dummy 'Dicky Mint'. He only really developed as a comedian with the advent of television, which also brought lots of radio work and, by the beginning of the 1960s, Ken Dodd was a household name right across Britain.

However, his first comedy act was based on the traditional stand-up routines that were popular at the time, and which comedians always ended with a song. This meant that audiences expected him to sing as he neared the end of his performances. Fortunately, Ken had quite a good voice, and his renditions of romantic ballads were good enough for him to be given the opportunity to make a record. In 1965 he recorded

'Tears', which went to No. 1 in the charts and stayed there for four weeks, He built on this success and, over time, recorded a further nineteen Top 40 hits and some top-selling albums. Indeed, his recording career lasted for over ten years.

Ken experienced a number of personal tragedies in his life, and his career also had a few ups and downs. One of the most public of these was in 1989, when, during a five-week-long trial, he had to answer charges of tax evasion. The case was heard at Liverpool Crown Court before a Liverpool jury so, naturally, Ken was acquitted.

Ken became renowned for many things, not least of all for the sometimes taxing length of his performances. He was also a passionate and lifetime supporter of Liverpool Football Club. His contribution to national comedy and entertainment was recognised when he was inducted into the Comedy Hall of Fame. What may be less well known outside Liverpool is the considerable amount of work that he regularly carried out for charity.

Ken always remained popular in Liverpool, not just because of his talent, but because of his loyalty. Unlike many local celebrities who 'make it big', he chose to continue to live in the city and this endeared him to the public. Ken was always a real 'son of Liverpool', as well as being a 'national treasure'. Even though the Inland Revenue might not agree!

In keeping with his status as a leading member of the local gentry, and with his 'Tickling-Stick' rampant, Squire Ken often celebrates and presides over the valuable estates of his Knotty Ash manor. He regularly tells his audiences about:

The World-famous Jam-Butty Mines
These are seasonal, of course, and by far the most popular flavour is syrup-of-figs, which gives the villagers of Knotty Ash that extra get-up-and-go!

The Snuff Quarries
These are quite close to the village so a lot of sneezing can be heard as you stroll through its leafy byways.

The Treacle Mines
These can be a bit deadly, as the pools of treacle sit in and around the local football pitch. This means that you can find yourself waist deep in treacle if you don't look where you are going. The sticky fluid is mined at night by the Diddy Men, and you can see them in the early hours of the morning with the pails of fresh treacle slung across their shoulders like milkmaids.

The Black Pudding Plantation
The heady fragrance of a new crop of black puddings as they dangle from the trees in gay profusion is a delight to the senses. However, if the wind is in the wrong direction and clouds of freshly quarried snuff are blown towards the plantation, this can taint the otherwise subtle flavour of this exclusively local fruit.

The Squire of Knotty Ash, Sir Ken Dodd, complete with tickling stick. (DL Library)

The Knotty Ash Moggie-Ranch

Knotty Ash Moggies are a very special breed of often feral felines, and it takes expert hands to breed and farm them, which is when the Diddy Men come into their own once more. They herd the moggies into their specially reinforced corrals with rare expertise and Scouse determination.

They are particularly proud of their skills with the moggies, and were delighted to display them publicly at the annual Moggie Rodeo, which is now, sadly, a thing of the past. You will know of the Rough Riders and Bronco Busting in America, but in Knotty Ash the Diddy Men would saddle up the moggies and then give displays of that very special Scouse skill of 'Pussy Busting'. Then, in teams, they competed in the 'Roping and Branding of the Pussies', which was a real sight to see.

But, the most thrilling spectacle of all came at the climax of the rodeo. This was when all the Diddy Men would get down and dirty in the middle of the arena, as they all took part in 'Freestyle Pussy Wrestling'. They really liked to show those pussies, and the delighted crowds, just who the bosses were in Knotty Ash.

As a great finale to the Moggie Rodeo, Squire Ken supervised a great village bun fight to which everyone was invited. Huge mugs of steaming stewed tea were served to wash down plates full of that very special treat, the surplus stock from Ken's Broken Biscuit Repair Works.

In December 2016, and at the age of eighty-nine, Ken received a long-overdue knighthood for Her Majesty Elizabeth II.

Pyramid Tomb of Rodney Street

Rodney Street is one of the broad thoroughfares that run through the Georgian Quarter of Liverpool, just to the east of the city centre. It is named after an early nineteenth-century British naval commander and enthusiastic supporter of the slave trade, Admiral George Brydges, 1st Baron Rodney (1718–92). In its history the street has been home to many significant people, but only one of these lies in St Andrew's Churchyard on Rodney Street, in a tomb beneath a pyramid.

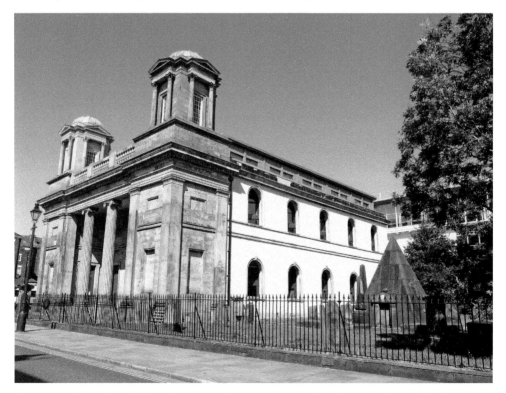

The former St Andrew's Church, now student accommodation. The burial ground is just to the right. (DL Library)

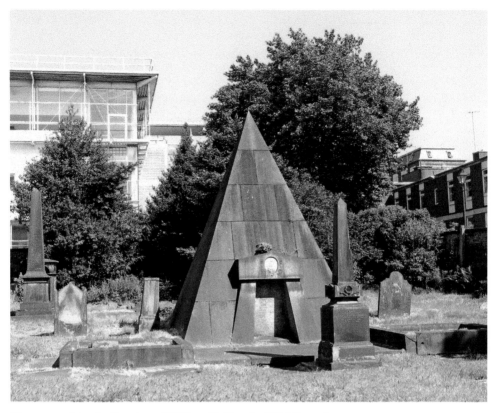

The unusual tomb of engineer William McKenzie. (DL Library)

His name was William McKenzie and he was born in Scotland in 1794. William came to Liverpool to follow his career as a civil engineer, building canals and railways in the burgeoning town. He was a great success and a pioneer in his field. He also won the respect of his peers and the admiration of the public. When he died in 1851, and as he had no children, the bulk of his £340,000 estate passed to his brother.

However, the fact that he died with such conspicuous wealth gave rise to much gossip: how did he amass such a fortune? Also, why is his tomb such a peculiar shape? Over time a legend grew to answer both of these questions and, in the last 150 years, this tale has become an established part of Liverpool folklore.

The story says that William McKenzie was an avid and always winning poker player. To guarantee his success at cards, the whispered story went, William had sold his soul to the Devil to be claimed by Old Nick, and according to the terms of a blood-signed pact, once William was 'buried beneath the ground'.

So, in an attempt to thwart the Devil, McKenzie reasoned that if his body was not buried under the ground then Satan could not claim his soul. This was why, in his will, the tale tells that he stipulated that he should be entombed above ground. He is also said to be seated upright at a card table holding a winning hand of cards and so

'cocking a snook' at the Devil. Because William had thwarted the precise wording of the pact, the Lord of Hell could not claim his prize of the canny Scotsman's soul.

Those who believe this story, and a surprising number of people do, say that he sits there still, inside the pyramid-shaped tomb in the centre of the graveyard. However, a ghostly figure wearing a frock coat and top hat is frequently sighted around Rodney Street, and its side streets and alleys. People say that this is the restless spectre of William McKenzie, denied eternal rest – so perhaps the Devil is extracting his due after all!

Despite the enduring popularity of this story, it is important to point out that the curiously shaped tomb itself was, in fact, erected seventeen years after McKenzie's death. The inscription on the door of the pyramid itself explains:

In the vault beneath lie the remains of William MacKenzie of
Newbie Dumfrieshire, Esquire,
who died 29th October 1851 aged 57 years.
Also, Mary his wife, who died 19th December 1838, aged 48 years,
and Sarah, his second wife who died 9th December 1867, aged 60 years.
This monument was erected by his Brother Edward as a token of
love and affection A.D. 1868.
The memory of the just is blessed.

So, this rather makes the story of McKenzie himself building the pyramid to thwart the Devil a bit redundant. But, as is so often the case, some people never let the truth get in the way of a good yarn!

St Andrew's Church itself was built in 1824 to serve the large community of expatriate Scots, of whom William McKenzie and his brother were members. It closed through lack of use in 1975, and was left derelict for decades following a vandals' fire in 1983. The building was rescued by Liverpool City Council in 2008, and the decay was halted.

The building has now been completely restored and refurbished, and has been converted into a very attractive complex of student apartments, while retaining all of the original, external architectural features. William McKenzie's pyramid-shaped tomb makes a very unusual ornament to the building, sitting in the centre of the graveyard next door. At least the students don't have noisy neighbours, nor do I imagine they get any complaints about any disturbance that they may cause!

Queensway Tunnel Portal

There are three transportation tunnels under the River Mersey that connect Liverpool with towns on the Wirral Peninsula. The first was the railway tunnel between Liverpool and Birkenhead. This opened in 1886, as then the longest such tunnel in the world. There are also two road tunnels beneath the river. One is named Kingsway and this runs between Liverpool and Wallasey. This was opened by Elizabeth II (b. 1926) in 1971.

The other Mersey Road Tunnel is named Queensway and connects Liverpool with Birkenhead. Work began on this, the first road tunnel under the river, in 1925. At the time of its construction the tunnel was the longest underwater road tunnel in the world at 2.13 miles long and it cost over £7.5 million to build.

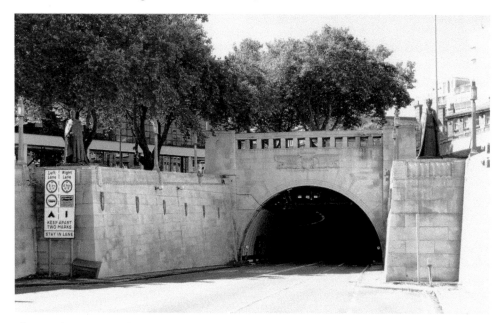

The art deco portal of the Queensway Mersey Tunnel, designed by Liverpool-born Herbert J. Rowse. (DL Library)

The Queensway Tunnel is now a Grade II-listed building. It was designed by the accomplished civil engineer Sir Basil Mott (1859–1938) and the inspired and respected Liverpool city engineer John Alexander Brodie (1858–1934).

The Liverpool entrance to Queensway sits on Old Haymarket, facing onto William Brown Street and the St George's Quarter. Its entrance portal is a glorious art deco statement of Liverpool's bold self-confidence in the 1930s. Its long, high curtain walls and wide archway, all in white stone, are another example of the fine work of architect Herbert J. Rowse, as are the adjacent structures and other buildings in the city associated with the tunnel. The walls of the entrance appear to sweep the traffic in and out, and striped classical reliefs add to this effect.

Above the tunnel mouth, standing one on each side, are slightly larger-than-lifesize flanking bronze statues of George V (1865–1936) and Queen Mary (1867–1953), who opened the tunnel in July 1934. These were sculpted and cast by the eminent artist Sir W. Goscombe John (1860–1952). In fact, it was Queen Mary after whom the tunnel was named.

Carved in the top of the wall that frames the entrance is a carved relief showing two winged bulls set on either side of a winged wheel. This image symbolises the swift and heavy traffic that uses this remarkable example of civil engineering. One of the original tollbooths still stands on an island near the entrance, and nearby is a tiled mosaic set in the pavement. This commemorates the inauguration of the tunnel, when the king and queen drove through it as passengers in the very first car to use the great underwater thoroughfare. However, there may yet be another tunnel under the river, but one of a great age and created for pedestrians, as shall be seen later in this book.

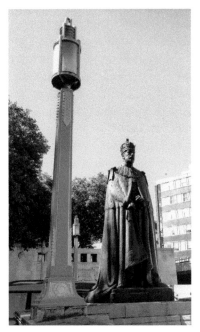

Left: The statue of George V, who opened this remarkable feat of civil engineering. (DL Library)

Right: Queen Mary, after whom the Mersey Tunnel to Birkenhead was named. (DL Library)

Royal Liverpool Philharmonic Hall – Classics, Catastrophe and Ancient Egypt

Hope Street is the long road that connects Liverpool's two cathedrals: the Anglican Cathedral of Christ, standing on St James Mount (Mount Sion) at one end, and the Metropolitan Cathedral of Christ the King, standing on Mount Pleasant at the other. Despite the spiritual implications of the road name, this is actually in commemoration of William Hope, a merchant who, in the late eighteenth century, first built houses on what was then a track out in the country.

Indeed, where those houses once stood, almost midway between the two great places of Christian worship, stands another temple. However, this one is dedicated to the enjoyment of and celebration of music – the Royal Liverpool Philharmonic Hall.

This dramatic but elegant building is reputed to have the finest acoustics of any classical concert hall in the world, and it is the home of the Royal Liverpool Philharmonic Orchestra, Choir, and Youth Orchestra. The orchestra is of the highest international standing and it was also the first in the world to have its own concert hall. However, this was not to be built until some years after the orchestra had been established.

The original Philharmonic Orchestra, now the Royal Liverpool Philharmonic Society (RLPO), gave its first performance on 19 March 1840 in Mr Lassell's Saloon, which was a dancing academy in Great Richmond Street. In 1843 the society moved to the hall of the recently built Collegiate School in Shaw Street, Everton, which was then known as Liverpool College.

However, the school hall was not ideal, either acoustically or in terms of other amenities, and in 1844 the committee of the Philharmonic Society instructed the architect John Cunningham to prepare plans for a new concert hall. This was to be built on the newly developed and highly fashionable Hope Street. Cunningham's plan was for a hall designed to seat 2,100 people, and with 250 orchestra and chorus seats. The foundation stone of the new building was laid in 1846, and construction began the following year. The new concert hall was opened in 1849, and the Liverpool

Philharmonic Orchestra went on to establish itself as one of the finest orchestras and choruses in Britain.

Throughout the latter half of the nineteenth century the reputation of the orchestra was growing in stature, and they were now performing in concert venues all over Britain. This recognition developed internationally, especially during the early decades of the twentieth century. Also, back home in Liverpool, the Philharmonic Hall was attracting large crowds of concertgoers for each performance.

But then, on 5 July 1933, a stray spark in the organ loft ignited a fire that swept quickly through the entire building. Despite the best efforts of the fire brigade, the Philharmonic Hall was completely destroyed. Nevertheless, the Philharmonic Society and the people of Liverpool were not daunted and by 1939 sufficient funds had been raised to see the present Philharmonic Hall erected in its place, on the same site.

The new hall was designed and built by Herbert J. Rowse, who, as we have seen, designed many of Liverpool's most famous buildings during the 1930s. Rowse decorated his new concert hall with Egyptian motifs, because his design concept was influenced by the discovery of the tomb of the Pharaoh Tutankhamen in 1922. Indeed, Egyptian ornamentation formed one of the main design influences of the art deco style for the same reason.

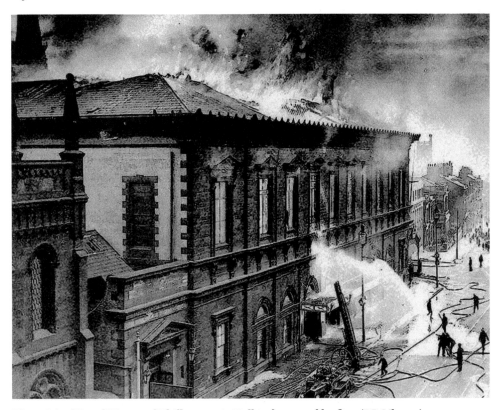

The original Royal Liverpool Philharmonic Hall is destroyed by fire. (DL Library)

The windows contain glass etched by Hector Whistler (1905–78), and the auditorium of the hall is adorned with very appealing panels. These show Greco-Roman female figures performing various dances in equally various states of undress. In the grand foyer are two large sculpted panel scenes showing 'Apollo being instructed by Pan', and 'Apollo enchanting the world by his art'.

All of these enhance significantly the overall aesthetic appeal of the building and were the work of Edmund C. Thompson (1898–1961). Thompson's beautiful sculptures and carvings adorn and grace many of Rowse's Liverpool buildings, and the two artists worked closely together.

In the entrance foyer of the concert hall is a memorial plaque that is dedicated to the musicians in the ship's band aboard the ill-fated transatlantic liner RMS *Titanic*. On the night of 14 April 1912, these gallant men in an attempt to keep up morale among the desperate and panicking passengers continued to play as the vessel was sinking. Their playing was heard by some of the few passengers who had managed to get into the lifeboats, and their final melody was the popular tune of the day 'Song of Autumn', not, as is so often reported, the hymn 'Nearer My God To Thee'.

The band were still playing as the great liner upended and split in two, before slipping forever beneath the icy waters of the North Atlantic. All the musicians perished, and their names are recorded on the plaque in tribute to their own courage and sacrifice. When the wreck of *Titanic* was discovered, in 1985, subsequent salvage expeditions recovered many items from the surrounding debris field. Among these was the cornet owned by one of the musicians.

Cinema also has a place at the 'Phil'. The concert hall houses a large, magnificently ornate, and full-sized cinema screen that rises up through the floor of the concert stage and on which are shown seasons of classic films. This is now the only fully functioning such elevating cinema screen surviving in Europe.

Always imaginative, in 1994 the Royal Liverpool Philharmonic Orchestra was the first in the world to play underwater. This was during the special 60th Anniversary Celebration of the opening of the Mersey Tunnel between Liverpool and Birkenhead. The underwater roadway had been closed to vehicles for a day to allow people to walk through it. The orchestra played at the centre of the tunnel, directly on the boundary between Liverpool and the Wirral, entertaining the thousands of pedestrians who passed through it with a high quality performance conducted by Carl Davis (b. 1936).

Everyone knows about Liverpool's connection with the world of rock and pop music, because of the Beatles and other homegrown pop musicians and singers, and an illustrious association it is too. Nevertheless, one thing that the existence of the 'Phil' demonstrates is that our association with classical and more serious music is just as distinguished. In 1901 the first performance of Elgar's 'Pomp and Circumstance March No. 1' was given at the original Royal Liverpool Philharmonic Hall. The composer dedicated it to Alfred Rodewald who, at the turn of the century, was a great patron of the 'Phil'. Also, the first performance

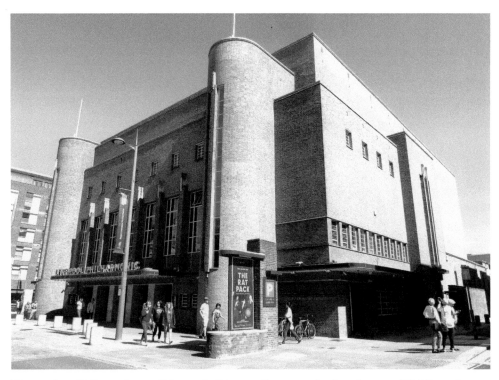

The modern Phil stands as a fulcrum in Liverpool's arts and cultural scene. (DL Library)

of Benjamin Britten's 'Young Person's Guide to the Orchestra' was given at the modern Phil in 1946.

The list of principal conductors of the Royal Liverpool Philharmonic Orchestra reads like a 'Who's Who' of twentieth-century classical music. This includes Zeebrugge, Bruch, Richter, Boult, Hallé, Sir Henry Wood (who established the Prom Concerts at the Royal Albert Hall), Sir Malcolm Sargent, Sir Charles Groves, Libor Pešek, and Sir Simon Rattle. The orchestra's present chief conductor is the highly talented and respected Vasily Petrenko, who was born in St Petersburg, Russia, in 1976. He takes his rightful place in this list of distinguished senior musicians.

Likewise, the roll call of world-renowned classical musicians and performers who have appeared at the Phil and elsewhere in the city is amazing, and includes Franz Liszt, Felix Mendelssohn, Nicollo Paganini, Sergei Rachmaninov, Johann Strauss Snr., Pablo Casals, and Yehudi Menhuin. Also, Jenny Lind 'The Swedish Nightingale' sang here; John Philip Sousa was here in 1905; Giacomo Puccini in 1911; and George Gershwin in 1929.

For more than 176 years the Royal Liverpool Philharmonic Society, its orchestra and its choir, have been at the heart and soul of Liverpool and Merseyside's cultural life. Long may this continue!

Stanlawe Grange –
The Tunnelling Monks

The oldest continually occupied building within the city boundary of Liverpool is believed to be Stanlawe Grange. This former barn and farmhouse, dating from around 1290, stands at No. 2 Aigburth Hall Drive, on the edges of Garston. This structure is the only surviving evidence that Cistercian monks had once settled in this part of what was then South Lancashire. However, the monks had come to this area from the other side of the River Mersey.

For around 300 years, until the Reformation in the early sixteenth century, much of the Liverpool area, as well as significant areas of North Cheshire and the Wirral Peninsula, was owned or occupied by the Cistercian Order of Monks. This Christian community had their principal monastery at Whalley Abbey near Clitheroe, plus a small but important community of monks at Stanlawe in Wirral, on the banks of the Mersey.

Having become well established in this district, in 1178 the order built an abbey here. This once stood on an area of marshland that now lies between modern Stanlow Oil Refinery and the Manchester Ship Canal. In the twelfth century the River Mersey teemed with fish, and the land on the Liverpool side was particularly rich, fertile, and well irrigated by freshwater streams. So, to provision their local religious community and to generate income, the Cistercians wanted to take advantage of this but first they needed permission.

In 1264 they approached Adam of Garston (d. 1265), the lord of the manor of what are now the Liverpool districts of Garston, Aigburth, and Speke. These still border the river and, from his family seat at Aigburth Hall, which was demolished by the 1840s, Adam agreed to allow the Cistercians to farm on his estates. The monks began to breed pigs in the part of the manor named Spic, which is now known as the district of Speke. This name comes from the Anglo-Saxon word 'spic', meaning 'bacon'. They also grew cereals and other crops in farmlands at Ackeberth, meaning 'place of many oaks', now known as Aigburth, where they also built granaries. They also bred livestock at Gaerstun, meaning 'grazing settlement', now known as Garston.

For many years during the Middle Ages the Cistercians also held extensive fisheries in Garston, specialising in flat fish and shrimps, which were sold in nearby Liverpool

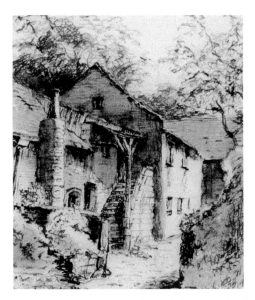

Above left: The Stanlawe Grange Granary in the eighteenth century. (DL Library)

Above right: The Granary as it looks today. (DL Library)

Town and in the surrounding villages. They also operated a number of watermills, which were fed by a stream that has its source in Allerton. This stream still runs to the river under modern Garston, but now through a culvert that was specially constructed in the nineteenth century as the village expanded and began to become industrialised.

The monks built the largest of their granaries, and which they named the Grange, as a large, cruck-frame barn. The great pegged oak beams forming the frame of the building survive, as does much of the 2-feet-thick, red-sandstone brickwork. The ground level was for the housing of livestock and storage of produce, especially during the winter, and there was an upper level with accommodation for three or four lay brothers. Their comfort was attended to, again particularly in the winter, by the fact that the cavity walls of the building were insulated with corn husks. The Grange had a detached hall, a barn, stables, a separate granary, and other outbuildings. The complex was overseen by a senior cleric, known as a 'granger', with direct authority from the abbot.

Nevertheless, to farm the land on the Liverpool side of the river, and to maintain the livestock and service the Grange, the monks would have needed to regularly travel across the Mersey. This would have obliged them to sail or row across the often turbulent waters of the river from Stanlawe to Garston. However, to enable them to still work their mills and farm their lands at Liverpool, local legends say that when the river was too wild to navigate the Cistercian monks walked through a tunnel under the river.

This directly connected their Lancashire holdings with their monastery in Wirral. To create this subterranean passageway the intrepid clerics excavated and extended natural caverns and openings beneath the Mersey by hand, and the legends about this may indeed have some basis in fact. This is because Wirral, just like Liverpool,

The front of the grange today showing many original features. (DL Library)

The rear of Stanlawe Grange with its delightful garden. (DL Library)

is riddled with underground tunnels and caves, many of which are natural but many more are man-made.

What must have been a twisting and rugged route, lit only by tallow lamps or candles that they would have carried with them, the monks made their way to their farmlands.

In 1279 Stanlawe Abbey was flooded and damaged; in 1286 its tower fell down; and in 1289 it was ruined by fire. This was too much for the monks, who moved back to their main house at Whalley. By 1294 there were only five monks and the abbot left at Stanlawe, with one residing at the Grange at Garston. They finally left the area entirely, including the Grange, during the Dissolution of the Monasteries in 1538, in the reign of Henry VIII (1491–1547).

Although both sides of the river have now been heavily built over, what may well be the entrances to this legendary tunnel have been discovered at both Stanlow and at Garston. Nevertheless, these are securely sealed and disguised to deter any would-be, latter-day 'Indiana Joneses' from exploring further. We shall just have to wait for chance, accident, or archaeological perseverance to either prove or disprove the legends of the 'First Mersey Tunnel'.

The ancient complex of buildings in Liverpool then became a working farm and farmhouse, although most of the outbuildings had been demolished by the outbreak of the Second World War. Then, in 1964, Stanlawe Grange was sympathetically restored and converted into two adjoining private houses. These are not open to the public, but the evidence of the ancient history of the building is clear from the outside of this important and fascinating, medieval monastic farmhouse.

Titanic Hotel and Tobacco

One of the most recent architectural developments in Liverpool is the new Titanic Hotel, which has been constructed in one of the port's nineteenth-century tobacco warehouses overlooking Stanley Dock.

Liverpool, and its city region, is now one of the most popular tourist destinations in the world because of its architecture, history, its music (not least of all the Beatles), its events and festivals, its world-class football teams, its river, its spectacular waterfront, and its 7 miles of tremendous regenerating docklands. This means that the demand for hotel accommodation of all types continues to increase, and not just for tourists but also for business people.

While a number of this new wave of hotels, guest houses, and suites are new builds, many are conversions of existing, often previously empty, but all beautiful character buildings. So, not only is this surge supporting Liverpool's growing economy but it is helping to restore and preserve the heritage of our built environment. This is certainly the case with the Titanic.

The hotel, on the face of it, does not have the most auspicious title, being named as it is after the ill-fated luxury liner. The ship *Titanic* was a massive, Liverpool-registered White Star vessel that, as we have seen, struck an iceberg in 1912 while crossing from Ireland to New York. It sank with the loss of over 1,500 lives. The Hotel Titanic, however, is already proving to be extremely popular with tourists, business people, and conference delegates alike.

It has 153 rooms plus extensive conference and event facilities, as well as excellent dining. A particular feature is that the hotel contains a replica of the grand, sweeping, first-class passenger staircase from the ship, which itself was a replica of the staircase in Belfast Town Hall. This all sits inside a beautifully engineered and artistically designed former tobacco and rum warehouse. This was built, between 1852 and 1856, by one of the port's most respected and renowned dock engineers, Jesse Hartley (1780–1860), and it is now Grade II listed.

The first shipment of tobacco from Virginia, America, had arrived in Liverpool in 1648. Once this trade took off, huge warehouses were needed to supply Liverpool's servicing of an increasing national demand for the addictive plant. Tobacco is a

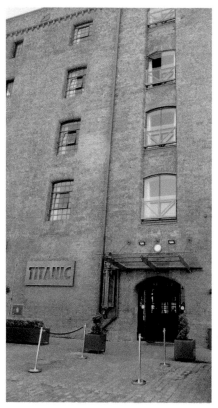

Left: The main entrance to the Titanic Hotel, in the former tobacco warehouse. (DL Library)

Below: One of the hotel's spacious dining rooms. (DL Library)

seasonal crop, and to keep markets stable, ports like Liverpool needed to store enough to last all year.

In fact, Hartley built two matching warehouses, sitting on either side of the broad dock basin that is now a major feature of the modern hotel complex. This is fed by the Leeds–Liverpool Canal and the waters flow past the end of the hotel, under a working bascule bridge that carries the dock road, and out into the rest of the dock network. In fact, Stanley Dock is the only 'inland' dock in the entire system, all the others (and their adjoining wharves, harbours, warehouses, and buildings) were all reclaimed from the river.

As one sits on the quayside of Stanley Dock, sipping a cocktail or tucking into an afternoon cream tea, one cannot see the warehouses partner, which itself is currently undergoing major refurbishment. Instead, the view is obscured and dominated by what is claimed to be the largest brick-built building in the world – the main, Stanley Dock Tobacco Warehouse.

This colossal structure was built, between 1897 and 1901, using 27-million bricks, and it takes up the entire length of the dock. It is 725 feet long and 165 feet broad, and stands about 125 feet high from the street level. It has a cavernous basement, a quay floor, and twelve upper floors. When it was opened, it had 1.3 million sq. feet of space, with capacity for 70,000 casks and bales of tobacco on a floor area of about 36 acres. It is so big that St George's Hall could fit inside it completely. During the Second World War it was used as a major supply base for the US Army and, in 1942, it was visited by Eleanor Roosevelt, the wife of the American president.

Unfortunately, with the seemingly terminal decline of Liverpool's maritime trades and its docklands after the Second World War, all three of the great tobacco

The great tobacco warehouse dominates Stanley Dock. (DL Library)

The Titanic obelisk stands in tribute to the stokers and engineers who gave their lives in their attempt to keep the lights burning on the stricken vessel. (DL Library)

warehouses had fallen completely out of use and were derelict by the early 1980s. Hampered by a lack of suitable uses for the massive buildings, as well as by a lack of money and Grade II-listed building status, the future seemed grim.

But, at a cost of £36 million, the Titanic Hotel has risen like a phoenix from the ashes. These flames of enterprise have also sparked off the complete refurbishment of the second, original tobacco warehouse as well as the greatest of the three. Redevelopment work is currently underway on both of these, costing a further £130 million. In just a few years' time the Titanic Hotel will then be joined by apartment and business developments; leisure, retail, and entertainment facilities; restaurant and sports attractions; as well as by more long and short stay hotel accommodation, all contained in and around the former warehouses now named the 'Ten Streets' district.

With more canal boats using the Leeds–Liverpool Canal, and sailing into and beyond the dock into the rest of the Liverpool waterfront, a whole new community of residents, workers, and tourists will continue the reawakening of Liverpool's once redundant north docks. These will all be living, working, and playing in and around some of the most impressive and historically significant industrial and maritime buildings in the world.

U

Underground War Bunkers

During the Second World War, after the fall of France in 1940 and before America came into the war in December 1941, Britain stood alone against the Nazi juggernaut that had rolled out across Europe. Liverpool was vital to the nation's survival because it was through the port that the convoys of ships to and from America, Canada, the Empire and, in due course, Soviet Russia, brought vital supplies to beleaguered Britain.

The country was not self-sufficient and the German dictator, Adolf Hitler (1889–1945), was perfectly aware of our dependency on these ships and our strategic position. He launched a relentless campaign of submarine U-boat attacks on the convoys under the command of Grand Admiral Karl Dönitz (1891–1980).

Against this the Royal Navy fought a determined resistance that became known as the Battle of the Atlantic. This was the longest running campaign of the war because it lasted for the entire duration of the conflict. The first attack on a British ship was the sinking of the SS *Athenia*, which was on its way from Liverpool to Canada. This occurred on 3 September 1939 only two days after war had been declared.

The last German attacks of the Battle of the Atlantic resulted in the sinking of the British freighter *Avondale Park*, of the Allied minesweeper *NYMS 382*, and of the Norwegian merchant steamer *Sneland*. These fatal assaults took place in separate incidents only hours before the German surrender on 2 May 1945. Nevertheless, during the war over 1,000 convoys successfully thwarted the German (and later Italian) submarines and entered Liverpool, bringing with them much-needed supplies of food, agricultural supplies, fuel, medicines, raw materials, and munitions.

It was not just supplies coming into Liverpool that had to be protected, because it was through the city's docks that 1,747,505 Allied Service Personnel passed on their way to and from the battlegrounds of the world. Indeed, during the war 4,648 special trains arrived at the Riverside Station (which no longer exists) at Princes Dock, from where these troops sailed from Liverpool. In fact, on one particular tide there were twelve ships queuing up in the River Mersey, waiting to pick up American soldiers from the Princes landing stage to take them to fight in Europe.

Children being evacuated from Britain and bound for safety in America and Canada also passed through Liverpool, and great ocean-going liners carried up to 2,000 of them at a time. All these transports were under constant threat of attack from the Nazi U-boats and they all needed protection. Tragically, not every ship reached its destination safely.

On 18 September 1940, the passenger ship SS *Benares* left Liverpool for Canada carrying ninety evacuee children among its passengers and crew. She was torpedoed by German submarine *U-48* and sank with massive loss of life, including seventy-seven of the children.

When the Second World War was declared, the operational headquarters for Atlantic Defence and Conflict was being constructed deep in the basement of Derby House, in Exchange Flags behind Liverpool Town Hall. Upon completion in 1941, this became the home of the Western Approaches Command, known as 'the Fortress'. It was from here that this desperate maritime conflict was fought, from 50,000 square feet of gas-proof and bomb-proof rooms beneath the streets of the city.

This complex of underground war bunkers is open to the public as a unique museum. The command offices, including where the British wartime prime minister, Sir Winston Churchill (1874–1965), worked when in Liverpool, and the radio and decoding rooms are all restored and contain much original equipment. Visitors can see the chart room, with its huge wall map of the Western Approaches, and the large table on which models helped plot the positions of the convoy ships and the U-boats, and where battle plans were put into action.

This crucially strategic command centre was led by Admiral Sir Max Horton (1883–1951), who directed his 'Scarecrow Patrols' to seek and destroy enemy U-boats in the North Atlantic Ocean.

From Liverpool, Atlantic convoys were always protected by an Escort Force, commanded by the well-respected Captain Frederick John 'Johnnie' Walker (1896–1944),

The entrance to the underground war bunkers – the Western Approaches Museum. (DL Library)

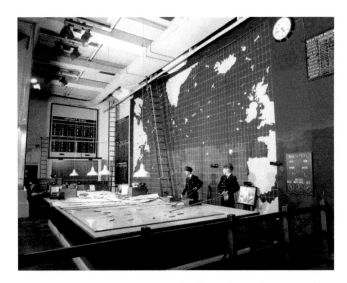

The great map and chart room in the underground bunkers. (DL Library)

The desk of Commander Max Horton, the Commander-in-Chief, and of Churchill when in the bunkers. (DL Library)

whose strategic and leadership skills were renowned. He had been about to retire at the outbreak of the war but agreed to take command of the 36th Escort Group based in the city, and he was very effective. Mentioned in dispatches three times during his career, Captain Walker was awarded the Distinguished Service Order on 6 January 1942, after his group sank five Nazi U-boats while escorting a convoy of over thirty vessels. In command of the sloop, HMS *Stork*, Walker fought and won many battles, and was awarded a bar to his DSO on 30 July 1942.

In 1943, Captain Walker took command of the sloop HMS *Starling*, and of the 2nd Support Group tasked with seeking out, attacking, and sinking enemy submarines. That year he succeeded in sinking six enemy vessels, and his actions continued with equal success; in January 1944 alone he sank a further five U-boats. Ships under the command of Captain Walker destroyed more enemy submarines than those of any

One of the many wartime propaganda posters on display in the museum. (DL Library)

other Allied naval commander. In 1944, on 22 February, he was awarded a second bar to his DSO, and later, on the 13 June, Captain Walker received his third bar.

Sadly, Frederick 'Johnnie' Walker suffered a brain haemorrhage in the summer of 1944 and died two days later, on the 9 July, in the Naval Hospital at Seaforth in North Liverpool. He was so respected by his men, fellow officers, and by the people of Merseyside that over 1,000 people attended his funeral, with full naval honours, in Liverpool Anglican Cathedral following an emotional procession through crowded streets.

'Johnnie' Walker CB, DSO and 3 Bars, RN, was buried at sea, and a life-sized statue of him, by renowned local sculptor Tom Murphy, stands at the pier head overlooking the river. There is also a large bust of him inside the Underground War Museum.

During the Battle of the Atlantic, and despite achieving ultimate victory, the Allied losses were astronomical, with the years 1941 and 1942 being the worst. Respectively, the Allies lost 1,300 and 1,661 ships in those years. In total, though, over 12.8 million tons of Allied and neutral shipping was destroyed, but the loss of life was the real catastrophe. Royal Naval losses totalled 73,600, with a further 30,000 sailors being killed from the Merchant Service, 6,000 from Coastal Command, and 29,000 from the Anti-German U-boat flotilla.

Churchill wrote in his history of the Second World War that, 'The only thing that ever really frightened me during the War was the U-Boat peril.' It is certainly true that the tenacity, skill, and courage of the people who worked in secret beneath Exchange Flags resulted in the Allied victory during the Battle of the Atlantic. Without this it is highly probable that Britain would have lost the fight against Hitler and his Nazis. This means that the significance of Liverpool in the history of the nation is much greater than most people realise.

V

Victoria Monument – Wireless and Willie

In 1901 Queen Victoria died, to the great shock of the British Empire despite her great age. Having been born in 1819, she had ascended to the throne in 1837, at the tender age of eighteen. Queen for sixty-four years, Victoria was the longest reigning British monarch until Elizabeth II, who was born in 1926 and ascended to the throne in 1952.

With the death of the old queen, just about every town and city in Britain (although not universally across the Empire!) wanted to mark her passing and pay tribute to her 'long and beneficent reign', and Liverpool was no exception. At the junction of Lord Street, Castle Street, and James Street is Derby Square. It was here that the city's commemoration monument was erected.

Unveiled in 1906, and funded entirely by public subscription, the stonework, the podium upon which the queen stands, and the columns and cupola that protect her were all designed by Professor F. M. Simpson and built by the firm of Willink & Thicknesse.

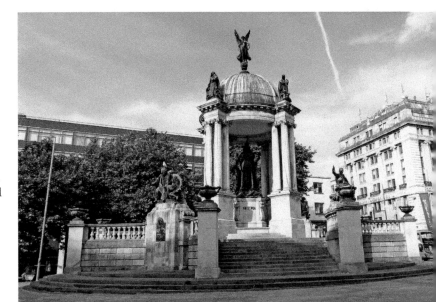

The full Victoria Monument in all its Edwardian splendour. (DL Library)

The statue of the queen and of fame (who surmounts the cupola supported by figures representing peace, charity, wisdom and justice) were all sculpted by Professor Charles J. Allen. The four groups around the base of the podium were the work of the same sculptor and these represent education, industry, commerce and agriculture. Indeed, if one studies the first of these groups, officially named learning, you will see a clearly academic, professorial gentleman.

He looks every inch the scientist, with a high forehead, bald head, and a long beard. This is Sir Oliver Lodge (1851–1940), who was the first professor of physics at University College, Liverpool, which went on to become the University of Liverpool. He was a pioneer in wireless, and he researched and developed electro-magnetism and the nature and propagation of radio waves. In 1888, he produced the first electromagnetic waves around wires and, on the 14 August that same year, he transmitted the very first radio signal, well before Marconi, who did not send his first, useful radio signal until 1901!

Even before the building of the Victoria Monument, Derby Square was a very important location in Liverpool. It was here, from the beginning of the thirteenth century and for 500 years, that the great castle of Liverpool stood. This formidable and grim bastion had been erected to defend what was then the new port and town of 'Leverpul'. At three of the castle's corners stood great, round, tall, crenellated towers. At its fourth, and facing onto Castle Street, was a great barbican tower. This had a portcullised entrance over a drawbridge across the deep, wide, water-filled moat that surrounded the entire structure.

Liverpool Castle served a major political and military role until after the English Civil War (1642–51) during which it had been badly damaged in the repeated sieges of the town. Afterwards it was used as a local quarry by the townspeople so, in 1726, it was finally pulled down and the site cleared.

Then, in 1734 the slender, graceful St George's Church was built in its place. With its tall, elegant spire, this was described at the time as being 'one of the handsomest in the kingdom.'

Liverpool Castle, the first structure to stand at what is now Derby Square. (DL Library)

St George's became the official church for the mayor and Corporation of Liverpool, but in 1863 the incumbent vicar, Revd James Kelly, gave a virulent anti-semitic sermon denouncing the choice of the new Jewish mayor for the town, Charles Mozely (1797–1881). To their great credit the entire congregation immediately stood and marched out of the building. They made their way down Church Street and into St Peter's Church (which I shall tell of later in this book). The local officials declared that this would now become the official corporation place of worship.

By 1887, the church had become redundant and somewhat dilapidated so, in 1889, it was demolished and the site cleared once again. The Corporation was debating what to do with the space when Victoria died. Now Derby Square would find yet another important purpose.

During the Blitz of May 1941, the German Luftwaffe completely devastated great swathes of the city centre of Liverpool, including the area surrounding the queen's large sculpture. It was considered an omen that, despite the appalling bombing that the city suffered, the old monarch remained standing, completely unscathed by the worst that Hitler could deal out. Because of this the monument deserves a closer inspection as one walks around this area.

There is, however, an unusual and controversial peculiarity about the figure of the great queen, which is best seen when one views the statue standing with one's back to Castle Moat House on the north side of the Square. It is from this position that one of the features of the sculpture can cause the viewer to question the gender of Britain's second-longest-reigning monarch!

Below left: The Church of St George that replaced the castle. (DL Library)

Below right: Queen Victoria on her podium. (DL Library)

Woolton Tudor Schoolhouse – Alma Mater of a Martyr

One of the most ancient and historically important of Liverpool's lost villages is Woolton. This sits to the south of the city between the other lost villages of Gateacre and Hunts Cross. There are many beautiful buildings in the village, of many architectural styles and periods, but the oldest and the quaintest is the Woolton Village Schoolhouse.

This stands, surrounded by trees, bushes, and gardens, in its own area of village green, on the bend in equally ancient School Lane. It carries a date stone reading '1610', although many historians believe it to be much older and that it was one of the earliest elementary schools in Britain. Indeed, the Gothic windows at either end of the building seem to indicate that it may well have been a pre-Reformation chapel.

There are many references to the schoolhouse in documents dating from the early seventeenth century and, in fact, the Catholic martyr Saint John Almond declared that he had been educated at a school in Much Woolton. It is probable that it was this same establishment.

John Almond was born around 1577 in the manor of Allerton in Liverpool, and he grew up there and in Woolton until, at the age of eight, he was taken to Ireland. As a young man John felt called to the priesthood so at the age of twenty he travelled to Rome. Here, he enrolled at the English College to study theology and in 1598 he was ordained as a priest. He returned to England as a missionary in 1602.

This was at a time when being a Roman Catholic in England was not only illegal but extremely dangerous, and so this proved for John. He was arrested in 1608 and imprisoned for a time. After his release, and with great faith and courage, he continued to preach and openly proclaim his Catholic doctrines. He was arrested again in 1612. This time he was found guilty of high treason, which carried the dreadful punishment of a protracted and excruciating death by hanging, drawing, and quartering. In November 1612, John Almond went to his death at Tyburn in London with great courage. In 1970 he was cononised by Pope Paul VI.

The schoolhouse in Woolton was unusually well built, with walls made up of stones 11 inches thick, some of which are four feet long. It is this quality of construction that has allowed the building to survive into modern times.

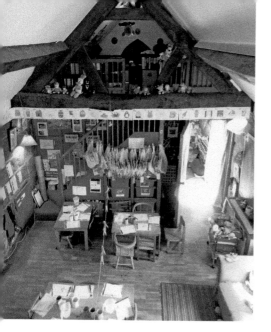

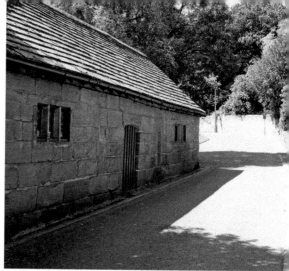

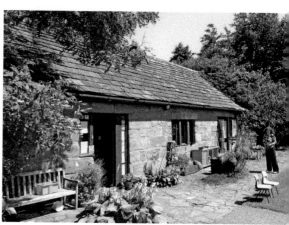

Above right: The ancient Woolton Schoolhouse. (DL Library)

Above left: Inside the schoolhouse where preschool children learn and play in historic but modernised surroundings. (DL Library)

Right: Dorothy Rood, the school proprietor, in the delightful and secluded grounds of the Woolton Schoolhouse. (DL Library)

The old school has also been a cottage, a barn, and a cowshed, but for much of the twentieth century it stood empty and derelict. Then, around 1985, it was bought by an architect who restored and modernised the interior and converted it into a dwelling where he lived for three years. It is a Grade II-listed building, so he retained all the stone work, mullioned windows, and the original oak beams. In 1988 he sold it and it reverted to being a school again, for nursery children.

In 2003, the present owner, Dorothy Rood, bought and upgraded it and landscaped all the surrounding gardens. Dorothy thoroughly modernised the building but retained all of the original period features, and continues to run it as a very popular and successful nursery school. This now has delightful learning spaces inside. It is also unique in that the outside areas include exciting areas of lawn, shrubs, bushes and trees for the children to play and learn in. These are entirely enclosed behind tall hedges and trees, providing a safe and happy environment for the small children.

It is wonderful that this ancient schoolhouse, in the twenty-first century, is still fulfilling the purpose for which it was built. I am sure that St John Almond would thoroughly approve.

'X' Marks the Spot

As mentioned previously, the great creek that rises in Moss Lake fields (modern Falkner Square) and the Georgian Quarter of the city, although now drained and culverted, completed its journey along what are now modern Whitechapel and Paradise Street. Before the creek was covered over and those roads were laid out in the early eighteenth century, the street we now know as Church Street and all the land from there up to where Liverpool Cathedral now stands was originally open heathland and grazing pasture.

Then, towards the final decades of the seventeenth century, there was a huge rise in the population of Liverpool and business opportunities began to rapidly increase as a result. Also, many people had come to the town following the Great Plague and Fire of London in 1666. It was this development that now persuaded local aristocrat, Sir Caryll Molyneux (1624–99), 3rd Viscount Molyneux, to build a new street down from the castle to the creek. In the eighteenth century his decedents would go on to become the Earls of Sefton.

The Church of St Peter, consecrated in 1704 and shown here in the early years of the twentieth century. (DL Library)

Molyneux named his new road Lord Molyneux Street, although today it is known simply as Lord Street. He also put a bridge across the creek and so opened up the heathland to development. The Corporation soon began to follow his lead and the new area began to be built upon.

Also, in 1699, to meet the spiritual needs of all the new people moving into the growing town, the ecclesiastical authorities created Liverpool as a parish in its own right, and in 1700 construction began on a new church on the other side of the bridge, on a continuation of Lord Street.

On the church site now stands Keys Court, the arcade entrance to Liverpool ONE. (DL Library)

The pediment of the building showing the relief sculpture of the crossed keys of St Peter. (DL Library)

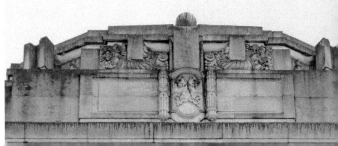

The Maltese Cross, set in the pavement, marks the location of the old church doors. (DL Library)

Until that time the town had only been a small part of the much larger and very ancient parish of St Mary's at Walton-on-the-Hill, to the north of the city. This was originally the parish church for the entire Hundred of West Derby. This was the administrative area of this part of South Lancashire, and it stretched from Ormskirk and Wigan, across to Warrington and Prescot, and down to Liverpool and the Mersey.

The new church cost £4,000 to build and was dedicated to St Peter. It was consecrated in 1704, and at that time it still stood among the open fields. Historians now believe that this was the first church to be built in Britain following the Reformation of the early sixteenth century. The track on which the new church stood was soon named Church Street, the name it retains today, although this remained unpaved until 1816.

During the next 200 years Liverpool's expansion was exponential and, in 1880, Queen Victoria granted Liverpool a royal charter to become a city, and it also now became a diocese in its own right. St Peter's was adopted as Liverpool's first cathedral, but it was soon felt that the new city deserved a much grander and significant building. In 1904, the foundation stone of a great neo-Gothic structure was laid by Edward VII (1841–1910), on top of St James's Mount (Mount Sion), and soon the Anglican Cathedral began to rise above the city.

This rendered St Peter's Church obsolete and in 1922, as part of the great widening of Church Street, the two-centuries-old building was demolished. It was replaced by the new Athenaeum Club building, and by a magnificent structure that contained a flagship Woolworths Store. This is now a range of modern retail outlets and an arcade entrance to the Liverpool ONE retail and leisure district.

Today, only three things remain to indicate that St Peter's Church ever stood here. One is in the name of the street, and the second is a large carved relief of crossed keys of St Peter, high up in the roof parapet of the building. The third relic is a brass Maltese cross. This can be clearly seen set in a granite slab, placed in the pavement beneath the crossed keys directly in front of the modern arcade, which is appropriately called Keys Court. The pavement cross marks the precise position of the doors of the old church.

Y

Yellow Submarine

The large recreation of the submarine vessel, which gave its name to the famous Beatles song and cartoon film, stands inside the central reservation in front of the entrance of Liverpool John Lennon Airport. This, though, is the city's second airport.

The first airport serving Liverpool and Merseyside was in the district of Speke, and so the terminal was known as 'Speke Airport'. This was officially opened in 1933, and the first ever flight from a regional airport to Europe took place from here in 1934. In 1950 the first scheduled passenger helicopter service in Britain also began from Speke, with flights to Cardiff. Then, in 1952 Britain's first package air holidays left from Liverpool, so this is indeed a significant airport. As a matter of fact, Speke Airport was established three years before Gatwick and thirteen years before Heathrow airports.

Even though the city suffered dreadful bombing during the Second World War, especially during the Blitz of May 1941, the airport, which was a major target, stayed open and fully operational throughout the conflict. On what was to become the post-war Dunlop factory, adjacent to the airfield, warplanes were built and then simply wheeled out onto the runway ready for action. From Speke, not only British pilots but Polish, Czech, and American airmen flew from Liverpool to take on the Nazis.

Following the construction of the terminal building, two large adjoining aircraft hangars were constructed. The first of these was designed and built by Fokker, the German military aircraft and engineering firm. This company submitted their bill for the construction work at Speke in the closing weeks of August 1939. The Nazis invaded Poland on the 1 September, and two days later the then British prime minister, Neville Chamberlain (1869–1940), announced that Britain was at war with Germany. The city of Liverpool knew only too well that Fokker fighter planes would be used against Britain and her allies, so they refused to pay the bill. To date, this remains unpaid. After the war, businesses were drawn to the airport and it became quite busy. However, as the rest of Liverpool, especially the docks, declined throughout the 1950s and 1960s, so did Speke Airport. Nevertheless, I can recall, as a child in the late 1950s, taking buses out to Speke to watch the aircraft taking off and landing. In later years, as a young man, I often dined out with friends in the lavish airport restaurant and bar, below the control tower in the main building.

When, in 1986, the new and relocated Liverpool Airport terminal was opened at Speke to meet the need for a much more modern facility, the original terminal buildings and hangars were closed down, and they fell into neglect and decay. Fortunately, as part of the regeneration of Speke and Garston in the 1990s, and thanks to funding from the European Union, the complex became a flagship redevelopment site for the area.

One of the old aircraft hangars became the headquarters of a telephone and online retail organisation, and the other opened as a state-of-the-art sports and leisure centre. The original terminal building was completely refurbished and is now a luxury hotel. All the classic thirties art deco architectural style and features of the building were retained in what is now a Grade II-listed building. This all pays homage to what was the first provincial airport outside London.

As part of a major rebranding process, and as a tribute to John Lennon (1940–80), the new airport terminal was renamed Liverpool John Lennon Airport, in March 2002, by John's widow, Yoko Ono (b. 1933). It was then subsequently and officially opened in July 2002 by Her Majesty the Queen. She also unveiled the first motto of the airport, which was taken from the lyrics of John Lennon's song 'Imagine', and quoted: 'above us only sky'

Liverpool John Lennon Airport is now one of the most successful and fastest growing in Europe.

The Yellow Submarine at Liverpool John Lennon Airport. (DL Library)

But what of the Yellow Submarine? The Beatles song first appeared on the group's 1966 album *Revolver*. It then featured in, and provided the subject and the theme for, their cartoon feature film in 1968. The image of the bright yellow fantasy submersible then passed into the iconography of the greatest pop group the world has ever known.

The vessel only then reappeared, and in a much more tangible form, in 1984. This was the year in which the International Garden Festival was held in Liverpool for five months during the summer. The large metal yellow submarine was built for the festival by apprentices of the Cammell Laird shipyards in Birkenhead. It was placed on display in a beautifully landscaped garden themed around the Beatles. This was just one of around sixty themed gardens, and the festival proved immensely popular and attracted 3.38-million visitors.

It was then possible to go inside the Yellow Submarine, which was appropriately themed and decorated throughout, and to climb up to its conning tower for views of the surrounding apple-shaped labyrinth garden. It is 51 feet long (15.6 metres), 15 feet wide (4.5 metres) and it weighs 18 tons. After the festival ended the submarine was placed in the original Chavasse Park in Liverpool city centre. It was later fully renovated and, although it is no longer possible to go inside it or climb on it, it was placed at the airport in 2005.

The general manager of the airport at the time, Neil Pakey, said, 'Other airports have the Concorde, we have the Yellow Submarine!'

Zoological Gardens Walton –
Pongo the Man Monkey

Our final port of call in this alphabetical gazetteer of 'largely unknown' Liverpool takes us to all that is left of the Zoological Gardens on Rice Lane in the district of Walton.

Zoos had always been very popular in the city and, over the centuries and at one time or another, they have also been located in Everton, Mossley Hill, Otterspool, and other parts of Liverpool. What was named the Liverpool Zoological Park and Gardens opened here, at the north end of the city, in the summer of 1884. Covering 30 acres it cost £200,000 to create, landscape and stock with animals. Among the many creatures on display, many of which, typically for the time, were allowed to roam freely, were exotic birds, small wildcats, African cattle, bears and leopards.

In a large, half-timbered monkey house were a number of apes and monkeys. One of these was the star attraction at the zoo and was advertised as 'Pongo the Man-Monkey: The Missing Link'. What type of ape he was is unclear, but he was large, agile and, according to reports, 'almost entirely human'. In fact, some visitors believed he was indeed a man inside a monkey costume. This is unlikely and he was probably a chimpanzee, a gorilla, or a large gibbon. Whatever, or whoever, he was his antics, acrobatics, and very human qualities regularly drew large crowds.

The pleasure gardens that formed a large area within the zoo were very attractive, with winding pathways around colourful flowerbeds, shrubberies, and wooded glades. A report on the opening of the zoo described a boating lake and a large tearoom built around a quadrangle planted with linden trees, 'to form a sylvan arcade for alfresco concerts'. The report continued, 'There is a spacious hall for concerts, dramatic and other performances, public meetings, and use of the terpsichorean art. The sides of the room are fitted up as alcoves upon a dais, with a promenade gallery overhead communicating with an external balcony on the same level.' It went on, 'All the highest points of the various structures will be illuminated by electricity."

Other attractions included a hotel, an elegant restaurant, a variety of shops, meeting rooms for learned societies, an allegedly 6,000-year-old Inca mummy, and a carved Maori temple. However, despite all of these delights and the daily firework displays,

by late 1885 the zoo was losing money. It was sold off by auction in March 1886, when it was bought for £200,000. It continued as a zoo but now on a much-reduced scale. Then, in 1887, it closed down for good.

Everything that could be sold off was disposed of, and the site was bought by the Liverpool Rubber Co. who built a large factory on the now empty land. In 1926 this became a footwear manufacturing complex and part of the Dunlop Rubber Co. By the 1930s over 3,000 people worked here producing 140,000 pairs of rubber boots and shoes every week. However, in the year 2000 this factory closed and was demolished soon afterwards.

A Sainsbury's superstore now covers the entire site and all evidence of the former Zoological Park and Gardens has disappeared: All that is except for part of the original ticket office and turnstile. This stands, facing onto Rice Lane, between the Lux Garden Chinese Restaurant and The Plough pub.

What can be seen now is only part of the original entrance gateway, and it consists of the turnstile entrance on the left of what are now shop premises, but that was once the ticket office. What reveals the original function of this small building, though, is the large, semicircular plaster panel above the modern shop window. This bears a design in relief showing monkeys swinging among vines, and another panel at the rear of this now shabby little structure repeats the design.

The ticket office was once famous for a large, gold-painted, bronze liver bird that was mounted over the entrance. This has long-since disappeared and its current whereabouts is unknown.

I have no idea what the future holds for the old ticket office, and I do not believe it is listed. I just hope that it has a future that will preserve this last remnant of a once important feature of the life of the Walton community and beyond.

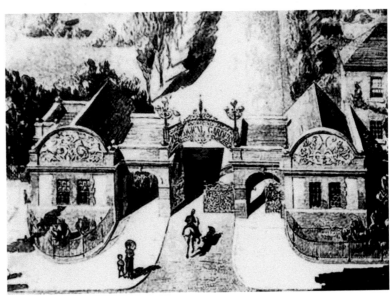

The original entrance to the Rice Lane Zoological Gardens. (DL Library)

One of the long streets that run off Rice Lane, almost opposite the old zoo site, is Rawcliffe Road. A walk up this leads to the very large Walton Cemetery, itself an historic location. The excellent Rice Lane City Farm can be found in the grounds here. So, the district's association with animals is still alive and well, if only on a very much smaller scale.

All that remains of the old ticket office and turnstile, alongside the Plough Pub. (DL Library)

The plaster relief showing twisting vines and climbing monkeys. (DL Library)

Acknowledgements

I certainly hope that you have enjoyed this tour through what I have chosen to call 'lesser-known' Liverpool. But this is only really the beginning. There are so many other wonderful stories to tell of the places, monuments, and people of the city and its suburbs that only a few people know well. However, these will have to wait for another time.

It was not a complex job to research the topics for this book, but what was difficult was deciding which ones to finally include. I thank my friends for helping me with this, but especially my children, Ben, Sammy, and Danny, and my wife, Jackie.

For the sources for my stories I would also like to acknowledge, as always, the professionalism and support of my fellow members of the Liverpool, Wavertree, Woolton, Garston, and Gateacre Historical Societies, the librarians of The Athenaeum, and the staff of the Liverpool City Records Office.

I would also particularly like to acknowledge the time and enthusiastic support of the following:

Heidi Birchall, ticketing and events manager, the Epstein Theatre
Pauline at Park Lodge
The Residents of Little Bongs
Sir Ken Dodd OBE
Michael Eakin, chief executive, Royal Liverpool Philharmonic Hall
The management and staff of the Titanic Hotel
The staff of the Western Approaches Museum
Dorothy Rood, proprietor, Woolton Schoolhouse
Robin Tudor, head of PR, Peel Airports Group
Vicky, head of Stadium PR, Liverpool Football Club
Jim Harding, Stanlawe Grange

Ken Pye FRSA: A Biography

Born and bred in Liverpool, Ken Pye has recently retired as the managing director of The Knowledge Group. In a varied career spanning over forty-five years, Ken has experience in all professional sectors. This includes working as a residential child care officer for children with profound special needs, as a youth and community leader, as the community development officer for Toxteth, the North West regional officer for Barnardos, the national partnership director for the Business Environment Association, and senior programme director with Common Purpose.

However, he continues as managing director of Discover Liverpool. As such, Ken is a recognised expert on the past, present and future of his home city and is a frequent contributor to journals, magazines and newspapers. He is also a popular after-dinner speaker and a guest lecturer to a wide range of groups and organisations. He is also a regular broadcaster for both radio and television. Ken is a fellow at Liverpool Hope University and a fellow of the Royal Society of Arts.

Well known across Merseyside and the North West, Ken is the author of over eleven books on the history of his home city and its city region, and is a widely recognised expert in his field. Ken's works include *Discover Liverpool* and *The Bloody History of Liverpool* (both of which are now in their 2nd editions); *A Brighter Hope*, a book about the founding and history of Liverpool Hope University; two volumes of his anthology of *Merseyside Tales*; *Liverpool: The Rise, Fall and Renaissance of a World Class City*; and *Liverpool Pubs*.

Having also completed two private writing commissions for the Earl of Derby, Ken has just issued his set of four audio CDs on which he tells his stories of the *Curious Characters and Tales of Merseyside.*

On a personal basis, and if pressed (better still, if taken out to dinner), Ken will regale you with tales about his experiences during the Toxteth Riots, as a bingo caller, as a puppeteer, as the lead singer of a 1960s pop group, and as a mortuary attendant.

Ken is married to Jackie and they have three children, Ben, Samantha, and Danny.

Visit Ken's website at www.discover-liverpool.com

Left: Ken Pye.

Right: The Pye family.